D1080418

30130 096887707

VAN GOGH

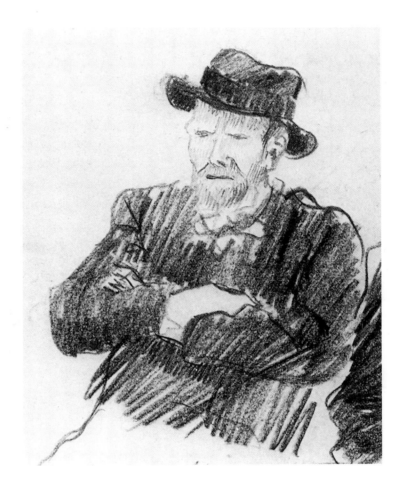

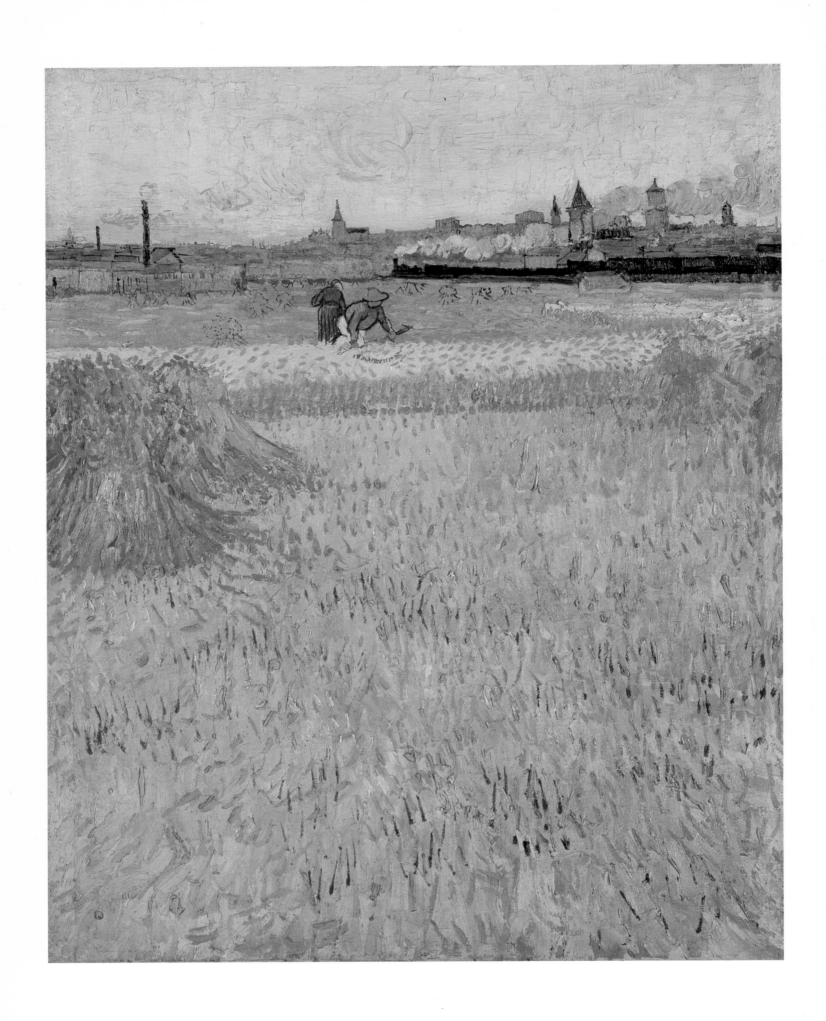

VAN GOGH

Caroline Earle

Grange
BOOKS

Published by Grange Books
An imprint of Grange Books PLC
The Grange
Grange Yard
London SE1 3AG

Produced by Saturn Books Ltd
Kiln House
210 New Kings Road
London SW6 4NZ

Copyright © 1997 Saturn Books Ltd

All rights reserved. No part of this
publication may be reproduced,
stored in a retrieval system, or
transmitted in any form or by any
means, electronic, mechanical,
photcopying, recording or otherwise,
without the prior written permission
of the copyright holder.

ISBN 1 85627 933 2

Printed in Singapore

PAGE 1: Lucien Pisarro's study of van
Gogh.

PAGE 2: **The Mowers**: see page 69.

BELOW: **The Ravine**, 1889.
Oil on canvas, 28¾ x 36⅛ in.
Bequest of Keith McLeod.
Museum of Fine Arts, Boston, MA

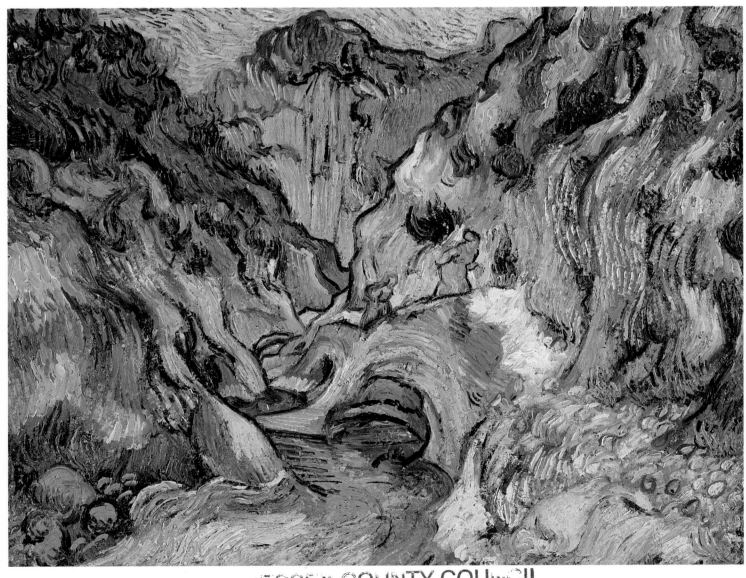

759
.949
2

ESSEX COUNTY COUNCIL
LIBRARIES

CONTENTS

INTRODUCTION

Not until he was 28 years old did Vincent van Gogh decide to become an artist, and over the following 10 years he produced an incredible range of paintings in many different styles. It is ironic that he lived most of his life in poverty, as today his paintings sell for astronomical sums, and he is widely regarded as one of the greatest influences on 20th century painting. Before painting became his life's work, van Gogh had tried a series of professions, but once he had embarked on his chosen path he never wavered, even during terrible periods of mental breakdown. Much acknowledgment for Vincent's perseverance must be given to his younger brother Theo, to whom he was very close and who throughout the artist's turbulent life was his emotional and financial bedrock. Vincent lived in over 20 places during his short life, and although the Impressionists and Japanese art counted among his biggest influences, he drew his greatest inspiration from his natural surroundings, which added to the development of his own unmistakable and individual style.

Vincent Willem van Gogh was born on March 30, 1853, in Groot Zundert, a small rural village in the

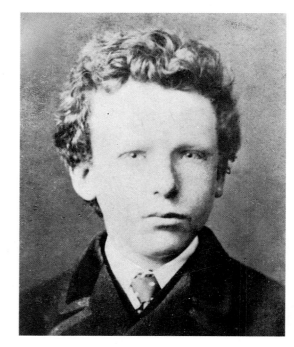

ABOVE: Vincent at the age of 13.

BELOW RIGHT: Van Gogh's mother Anna.

BELOW LEFT: Theo van Gogh.

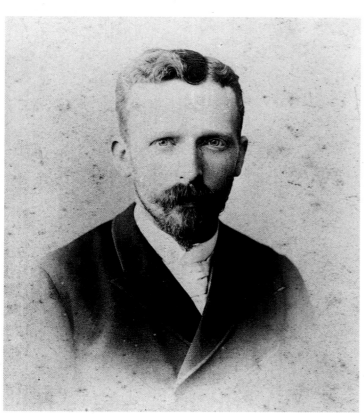

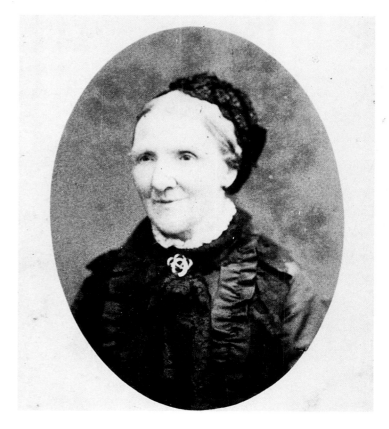

6

RIGHT: *The Sower*, painted by Jean-François Millett in 1850. (Oil on canvas, 39¾ x 32½ in.) Now in the Shaw Collection, Boston Museum of Fine Arts, this picture had a great influence on van Gogh.

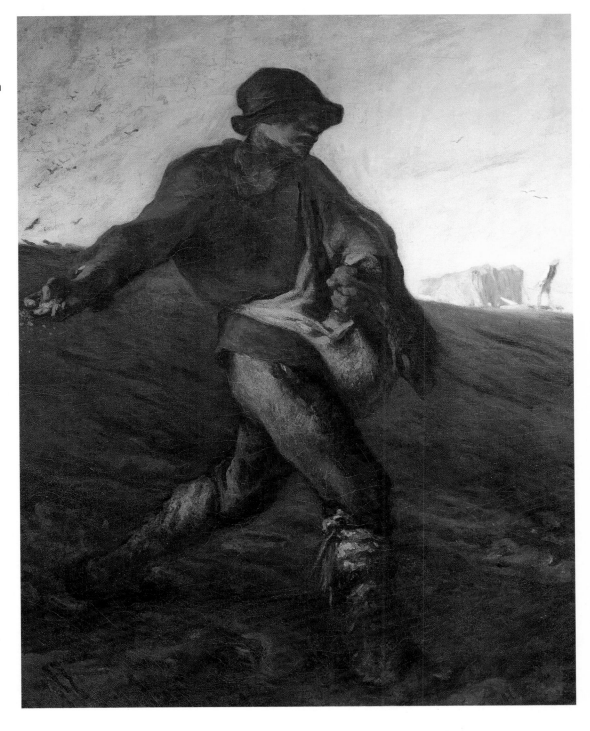

province of Brabant, south of the Netherlands, where his father Theodorus van Gogh was a clergyman. The eldest of six children, van Gogh's childhood appears to have been uneventful, and early accounts of him as a child describe him as awkward and solitary. Although he started drawing during his childhood, he expressed no great interest in art and gained his first job as an apprentice at the international art dealing firm of Goupil et Cie in the Hague through family connections, as his Uncle Vincent was a partner in the company.

This position opened up a whole new world for 16-year old van Gogh, as he left the quiet rural backwater of Groot Zundert to live in the Hague and become involved in the commercial world of art dealing.

Although engaged with menial tasks, he took the opportunity to absorb all that surrounded him and developed an extensive knowledge of art. He also began to read voraciously and visit museums, becoming a keen collector of prints and illustrations from magazines.

In 1873, after nearly four years in the Hague gallery, Vincent was transferred to Goupil's London branch, and at the same time his younger brother Theo also joined the firm. This marks the start of a remarkable lifelong correspondence between the two brothers from which much of the information about van Gogh's life is gleaned. Although separated by long distances for most of their lives, Theo and Vincent wrote to each other regularly, and Vincent often

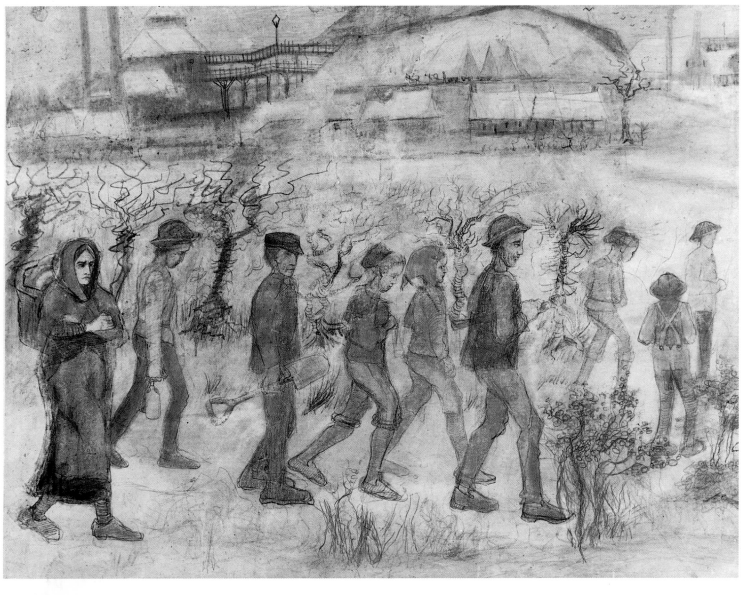

RIGHT: *Peasant woman and child*, 1883.

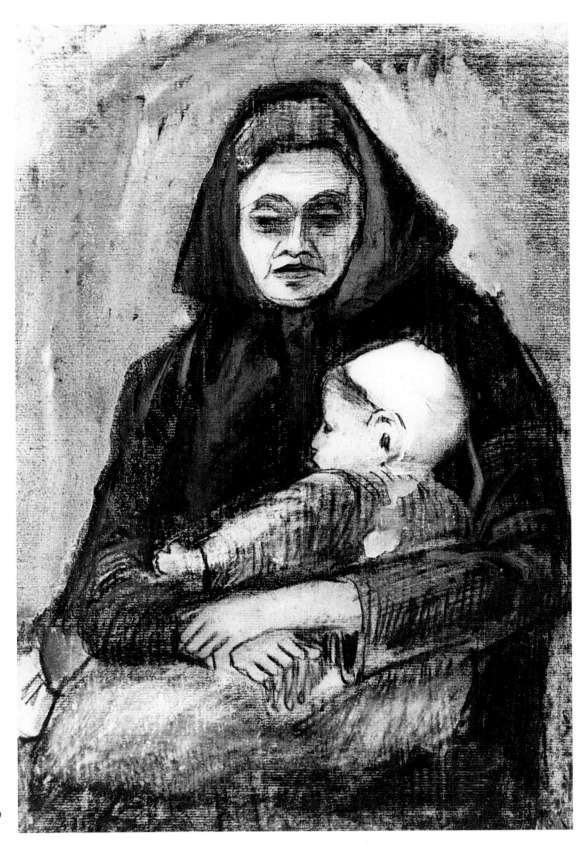

ABOVE LEFT: *The Sandpit*, one of van Gogh's earliest sketches.

BELOW LEFT: *Miners going to work*, 1880.

included sketches in his letters of places he had visited and of paintings on which he was working.

Moving to London was an exciting prospect for van Gogh as he was already a great admirer of English novelists, Dickens especially, and he approached his new appointment with enthusiasm. At the London gallery he was exposed to a wider range of art, and the influence of those artists he appreciated the most are evident in his own work. He particularly admired the members of the Hague School, especially artists such as Jules Breton and Jean-François Millet with their dark tonal paintings of peasant scenes. Van Gogh was also intrigued by 17th century Dutch painters (Hals and Rembrandt) with their emphasis on religious and moral themes. Most notably he discovered the work of contemporary English graphic artists in magazines such as *The Graphic* and *The Illustrated London News*. The themes of urban life covered in

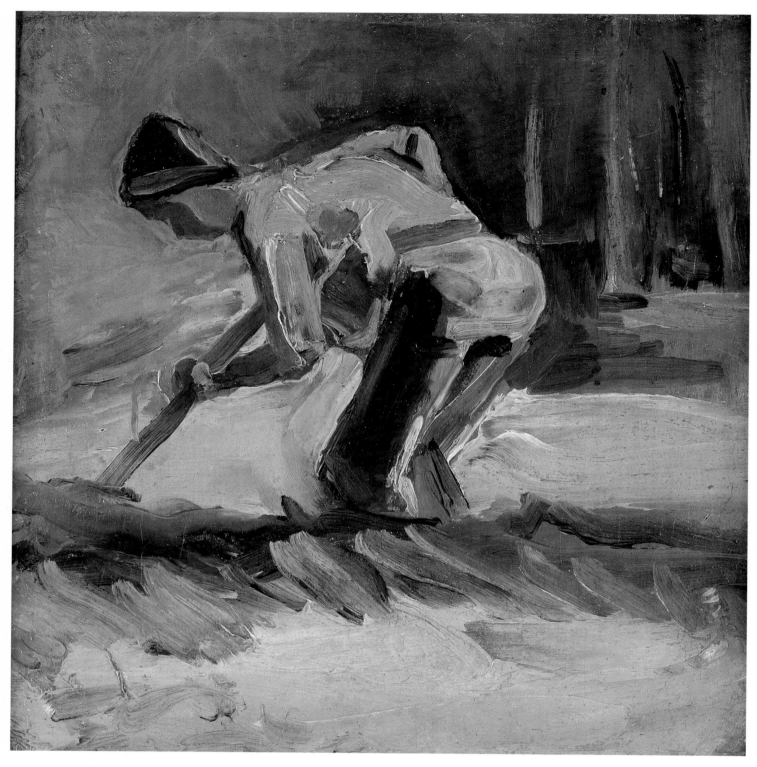

these periodicals and the hours van Gogh spent exploring London inspired him to start sketching. However, the artist's contentment collapsed after he was rejected by his landlady's daughter, Eugenia, with whom he had fallen in love. He was thrown into a deep despair, the first of many mental crises, and this rejection was to haunt him for many years. Anxious to find an outlet for his suffering, he immersed himself in religion, becoming more withdrawn and obsessed with the idea of devoting his life to helping others. His depression affected his work at the gallery and he became increasingly rude with customers. Prompted by his disturbing behavior, van Gogh's family arranged

for him to be transferred to the Paris branch of Goupil in May 1875.

Paris was the heart of an exciting and innovative art scene and van Gogh should have been in his element. However, still in a state of depression over Eugenia, he dedicated most of his time to religion and bible study. Nevertheless his interest in art and literature continued and he spent some time visiting museums and art galleries, but he was becoming increasingly disillusioned with the commercial art world and his attitude deteriorated to the point that he was asked to leave the gallery. Despite encouragement from Theo to try out a career as an artist, van Gogh's overriding

RIGHT: *Sorrow*, 1882, modelled by Sien Hoornik, whom van Gogh considered marrying.

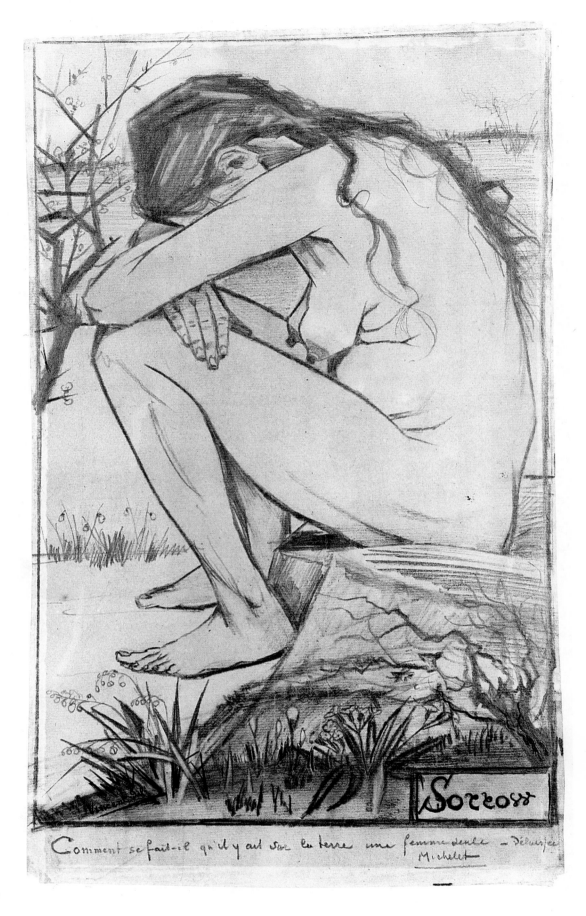

LEFT: *Man at Work*, oil on canvas, painted at Neunen.

ambition was to become a preacher in his quest to help the poor and the less fortunate.

A brief period spent as a teaching assistant in England, where he saw the terrible conditions of the students' families in the East End, only served to strengthen his resolve to devote his life to God and working with the poor. Intent on becoming a clergyman, he returned in December 1876 to Holland and, supported by his parents, went to Amsterdam where he failed to pass the entrance exam for the

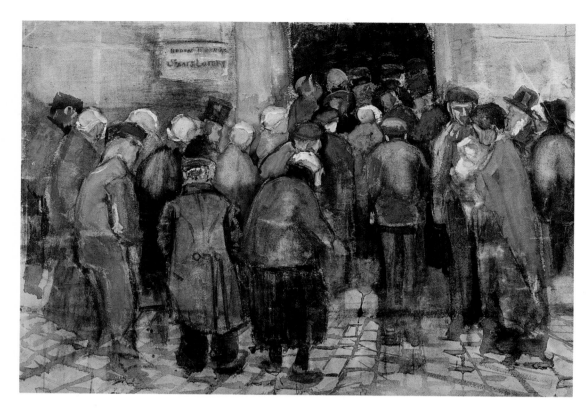

LEFT: *The State Lottery Office*, 1882. Watercolour on paper, heightened with white, 15 x 22⅜ in.

RIGHT: The Weaver, 1884. Oil on canvas, 24⅝ x 33¼ in.

BELOW: *Peasant Reaping*, August 1885, black chalk on paper.

Faculty of Protestant Theology. Finally, in November 1878 he succeeded in obtaining a lay-preaching post in the Borinage, a poverty-stricken coal mining area of Belgium. According to his vision of religious devotion he lived like his parishioners in extreme hardship, often giving away his own food and money to the

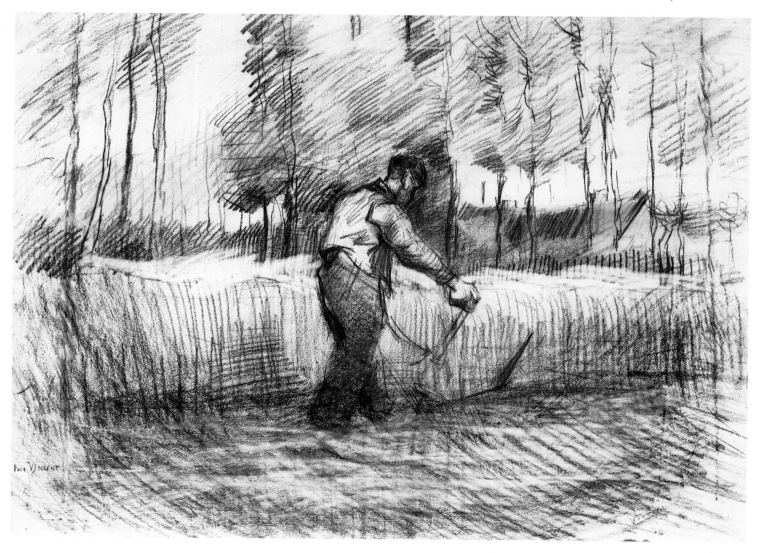

miners, but this behavior horrified his superiors and he was dismissed. Supported financially by Theo, he stayed in the Borinage, where he continued preaching independently, but he devoted more of his time to sketching the miners and their environment. His social concern now manifested itself in his drawing. Unfortunately during this time he suffered from severe depression and eventually returned home where, encouraged by Theo, he finally decided at the age of 28 to pursue a career as an artist.

Realizing that he needed to study art properly, Theo arranged for Vincent to study perspective and anatomy for six months with a young Dutch painter, Anton van Rappard, at the Academy of Fine Arts in Brussels. With fresh hopes for the future, he returned home in April 1881. Finding inspiration in Millet's work, he began to draw the familiar countryside and rural life surrounding him such as cottages, farms, and laboring peasants. Unsurprisingly, these sketches were not romanticized images of agricultural life, but instead mostly dark and starkly realistic images with harsh outlines.

Once again, as was to become the norm in van Gogh's life, this brief period of stability did not last. He slipped into yet another depression when Kee Vos, a recently widowed cousin who wished to remain faithful to her dead husband's memory, refused his ardent love and marriage proposal. Vincent's eccentric behavior precipitated a family quarrel, and he returned to the Hague and established himself there with his cousin-in-law Anton Mauve, a member of the Hague School which Vincent so admired. Mauve became his tutor and encouraged him to start painting in oils. Van Gogh's *Girl under Trees* (1882) displays his mentor's influence, but van Gogh's wish to portray more realism in his art led him to break away from Mauve.

The young artist then took up with a prostitute, Clasina Hoornik known as Sien, with whom he found some emotional fulfillment in caring for her and her child — the closest he would come to having a family of his own. He created many portraits of her, the most famous of which is the lithograph *Sorrow* (1882). Van Gogh depicted her sitting down, pregnant, with her face hidden behind her folded arms — a symbol of despair and the struggle for life in a cruel world. This tragic portrait hinted at the unhappiness of both Sien and van Gogh; her heavy drinking and increasing moodiness eventually prompted the artist to leave her. With help from his parents and Theo, he moved to Drenthe, where he tried to settle down to painting the

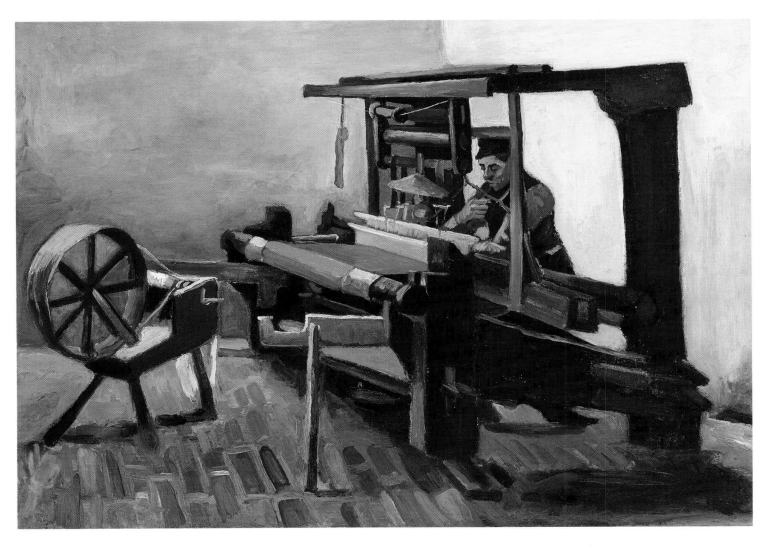

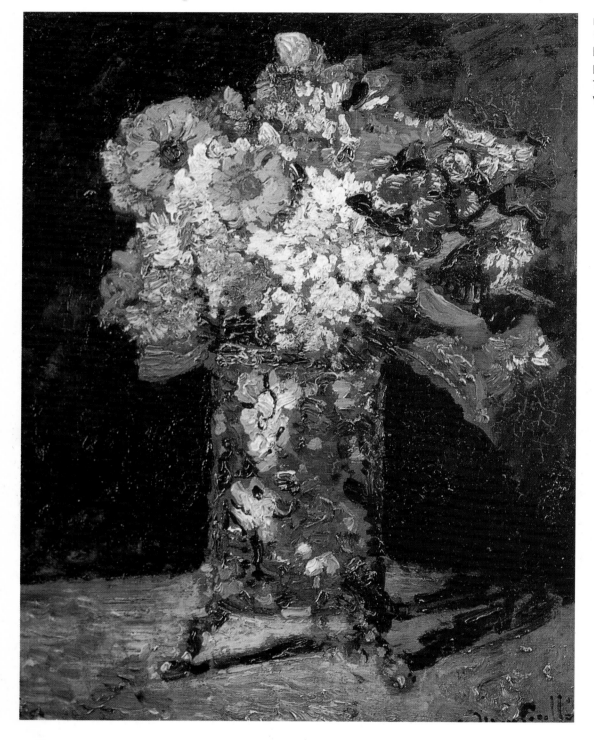

LEFT: Adolphe Monticelli's *Vase of Flowers*. Owned by Theo van Gogh, this painting influenced many of the still lifes completed while Vincent was in Paris.

life of the rural peasants, but the inhabitants, suspicious of his intentions, exacerbated his loneliness and drove him home to his family.

Beginning in December 1883 van Gogh spent two years settled near his parents in Neunen where he rented a studio and devoted his time exclusively to painting. He attempted to realize his dream of becoming a 'peasants' painter' and most of his work from this period depicted the daily life of the Neunen peasants in dark, somber tones reminiscent of Rembrandt's chiaroscuro. One of the most important works from this prolific period is *The Potato Eaters* (1885), a domestic scene of a family sitting down to share a meager meal, but this is no idyllic portrayal,

the subjects' faces are dark and ugly, showing the hardship of agricultural life. This piece was typical of van Gogh's wish to use painting to voice his social concern. Seeing himself as a champion of ordinary peasants and workers, van Gogh sought to capture the monotonous drudgery to which they were subjected in such paintings as *The Weaver* (1884) and *The State Lottery Office* (1882). By autumn 1885 however, relations with his mother had become strained after his father's death, and he yearned for a change of scene. Theo had now become manager of Goupil's gallery in Paris, and after reading his enthusiastic letters about the art scene, Vincent set his heart on living in the stimulating Parisian

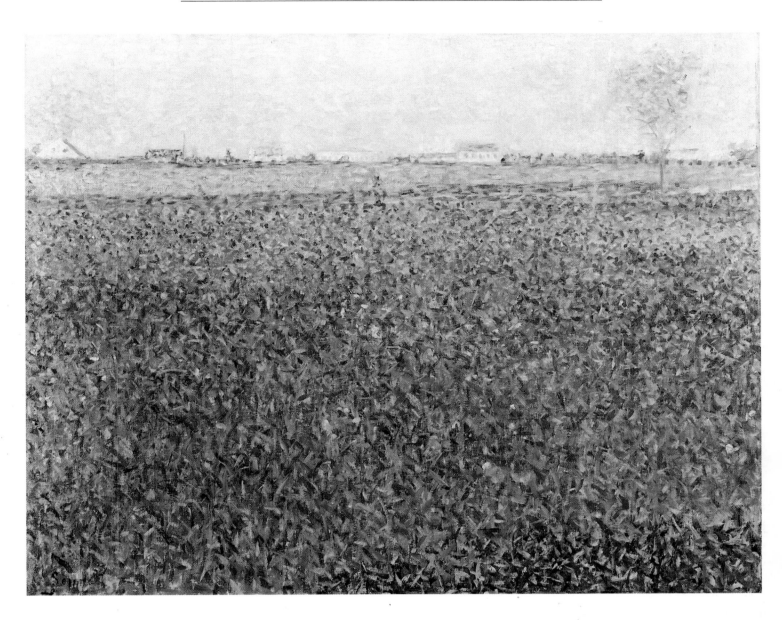

ABOVE: *Alfalfa at Saint Denis*, by Georges Seurat. The pointillist methods of Seurat influenced Van Gogh's technique.

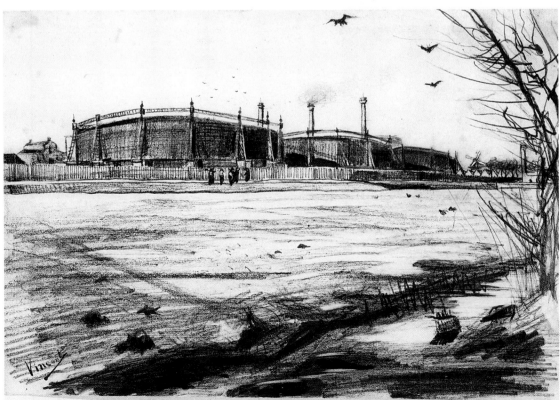

RIGHT: *Gas tanks in The Hague*, March 1882.

atmosphere. Before traveling to France's capital city, he stayed briefly in Antwerp, where he took painting classes at the Academy.

On arrival in Paris in February 1886, Vincent stayed at his brother's apartment and enrolled at the nearby studio run by the painter Fernand Cormon where Henri de Toulouse-Lautrec and Emile Bernard were among van Gogh's fellow students. Through his brother's connections in the art world, he came into contact with many up-and-coming young artists and Neo-Impressionists, including Camille Pissaro, Paul Gauguin, Paul Signac, and Georges Seurat. Influenced by the Impressionist movement, and the new techniques used by Seurat and the Neo-Impressionists, van Gogh began to move away from the dark tonality of his earlier works. Although his palette became lighter and more colorful, he developed his own style, experimenting with strong colors and different ways of applying paint. Inspired by the rich colors of Delacroix and Monticelli, he painted colorful, vibrant flower pieces and still lifes, such as *Poppies* (1886) and *Fritillaries in a Copper Vase* (1887). He spent many hours exploring Paris and its environs, and enthusiastically embarked on painting everyday street scenes, aspects of life in Montmartre, cafés,

gardens, and windmills. The Pointillist dot-stroke technique of Seurat, the influence of Impressionism, and the lightening of his palette can be seen in his Paris townscapes, such as *View from Rue Lepic* (1887) and *The Boulevard de Clichy* (1887).

However van Gogh only drew partial inspiration from Impressionism; he was also interested in the intensity of color. At this time Japanese art had become fashionable in the art world, and Vincent, who had discovered Japanese woodblock prints in Antwerp, made some copies in his own style. *Japonaiserie — Bridge in the Rain (after Hiroshige)*

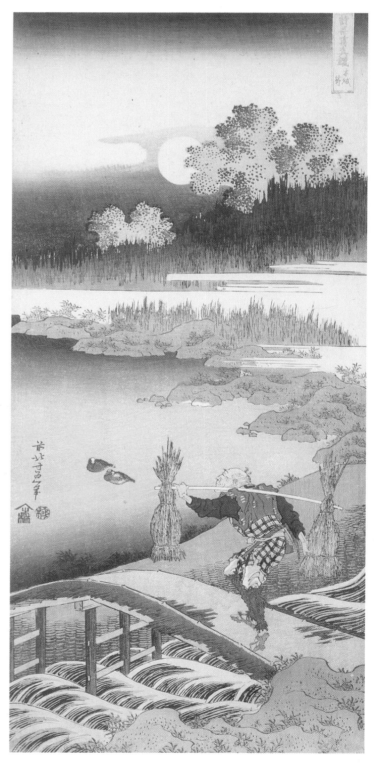

ABOVE: No 54 Rue Lepic, van Gogh's home in Paris.

RIGHT AND FAR RIGHT: Two Hokusai woodblocks. Japanese art heavily influenced van Gogh's drawing style.

(1887) is a stunning example of his interpretation of Japanese composition and color. Nevertheless his interest in the daily life of ordinary people never waned, and he made many portraits of the people he encountered, such as *Woman at Café du Tambourin* (1887) and, the most famous of his Paris period, *Portrait of Père Tanguy* (1887), an amiable old man who ran a paint shop and often allowed struggling artists to have paint and materials on credit or in exchange for canvases. In his depiction of Tanguy, van Gogh sets the central figure against a background of Japanese woodcuts. Unlike many of the artist's other portraits, the subject exudes warmth and amiability.

Although his art was developing in intriguing directions, van Gogh did not linger in Paris. His health was suffering because of his heavy drinking, and despite their close relationship, Theo found Vincent very difficult to live with because of his violent swings from extreme happiness to deep depression. Visits with Emile Bernard to Asnières, on the outskirts of Paris made van Gogh long for the country, and he had romantic visions of finding his own 'Japan', so he headed for the south of France.

When Vincent first arrived in Arles in February 1888, it was covered in snow which soon melted to reveal trees in blossom. He truly believed he had found an approximation of Japan. One of his early

works from this period, *Pink Peach Tree in Blossom* (1888), was painted in memory of his former tutor, Anton Mauve, and is evocative of the Japanese woodcuts which so influenced him in Paris. During the spring and summer in Arles he painted almost unceasingly and with great energy, inspired by the rich colors of Provence's blue skies and yellow sun. His colors intensified, and he became a master of complementary colors, exploring fully the luxurious combinations of blues and oranges, purples and yellows, and greens and reds. Van Gogh explained his fascination: 'The uglier I get, the older, nastier, sicker and poorer, the more I want to avenge myself by going in for brilliant, well-contrived, resplendent color . . . And to manipulate the colors in a picture so that they vibrate and set each other off.'

He painted all around Arles with its gloriously colorful landscapes, including fields (*Wheatfields*, 1888), harvests (*Haystacks in Provence*, 1888), vineyards, and town scenes. One of the few paintings van Gogh sold during his lifetime was *The Red Vineyard* (1888). Using heavy impasto, he provided a stunning contrast of autumnal reds and golds with the blues and blacks of the harvesters' clothing. The brilliant sun of the Midi held a great fascination for him, and both versions of *The Sower* (June and November 1888) are dominated by a huge blazing sun

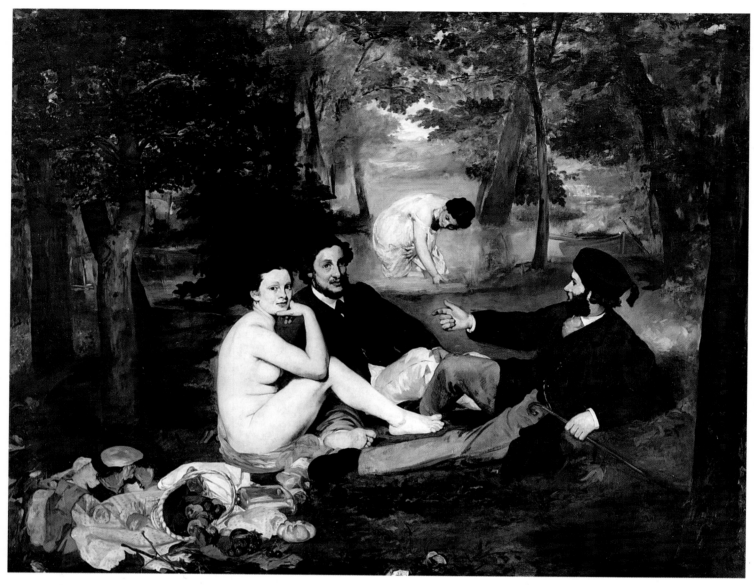

contrasting with the blues of the foreground. Representing the sun, yellow now became the most significant color for van Gogh, and nowhere is this better expressed than in his series of *Sunflowers* paintings which contain numerous variations of the color. Equally fascinating for van Gogh were the colors of the night, and he became determined to master the art of night painting. With candles fixed to the brim of his hat, he painted stunning night scenes including *The Café Terrace at Night* (1888) in which the bright yellow glow of the café lights are juxtaposed against the dark violet blue of the starry night. One of his most sinister paintings, *The Night Café* (1888), is an effective portrayal of the seedier side of life where blood red clashes with bilious green and insipid yellow. Van Gogh wrote that in this painting, 'I have tried to express the terrible passions of humanity by means of red and green.'

At first very lonely in Arles, van Gogh still had a desire to paint portraits, and halfway into his stay he was able to befriend a few people who would pose free of charge. Among these sitters was *Postman Joseph Roulin* (1888), a regular companion of van

Gogh's in the local café. Although Vincent had arrived in Arles on an optimistic and enthusiastic note, by the summer his loneliness had increased and a deep depression had set in. He began to focus all his hopes on a dream he had nurtured for several years: setting up an artists' cooperative, with Gauguin as the leader. He had started renting a house in Arles which he painted yellow (*The Yellow House*, 1888) and saw it as the venue for his 'school of the south'. In October 1888, after months of delay, Gauguin was finally persuaded (with financial help from Theo) to join van Gogh in Arles.

Although Gauguin and van Gogh's partnership had an auspicious start, inevitably their artistic differences emerged, and they quarreled. Gauguin was a Symbolist and thought his colleague should work from his imagination and paint from memory. Van Gogh did attempt to adopt Gauguin's style for *Les Alyscamps* (1888), but at heart he was a Naturalist and an advocate of realism in art, using color as his means of individual expression. The tension between the two temperaments increased and came to a head when after one particular dispute van Gogh threatened

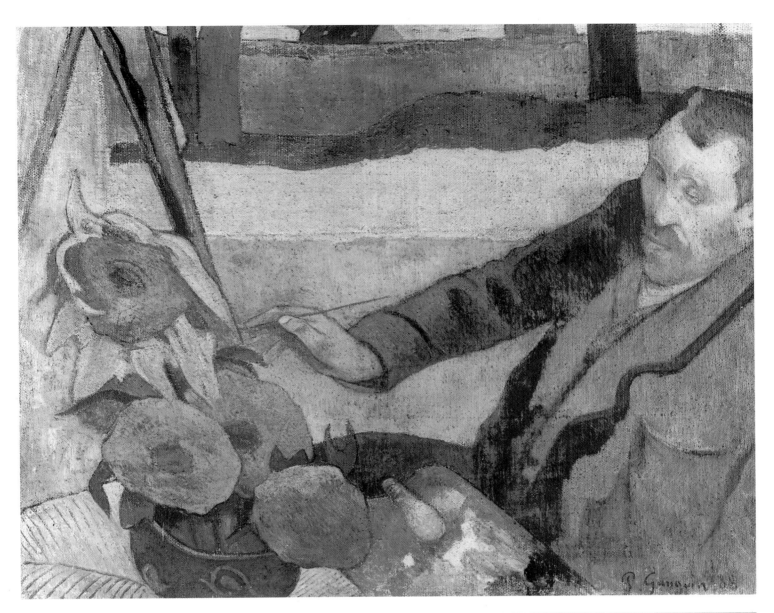

LEFT: Manet, too, was
heavily influenced by
Japanese art. Here his
Le Dejeuner sur l'herbe.

TOP: Gauguin's *Portrait of
van Gogh with Sunflowers*.
Painted in Arles in 1888.

ABOVE: *The Vicarage Garden
at Neunen*, painted in April
1884.

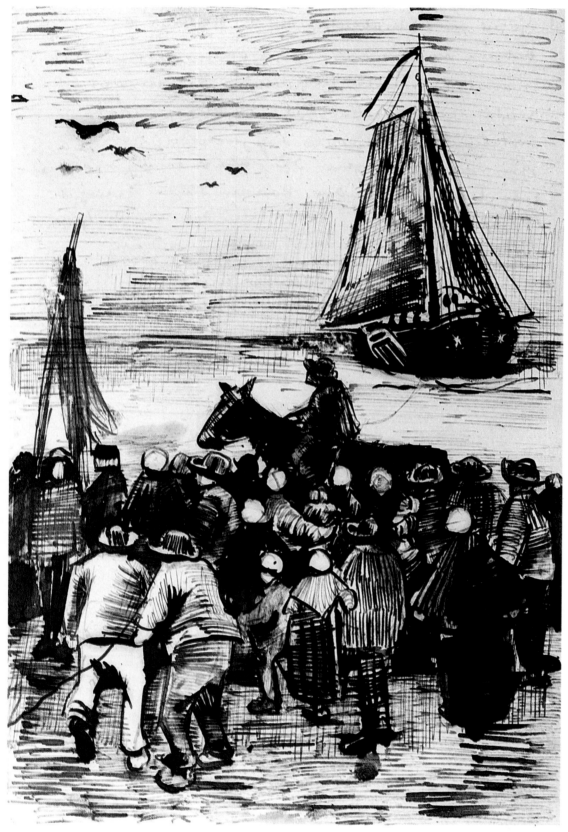

LEFT: A fishing boat sketched in a letter.

RIGHT: The asylum at St-Rémy, near Arles, where Vincent was treated for mental instability.

Gauguin with a razor blade. Later in a fit of mania he cut off his own ear lobe, wrapped it in newspaper, and ran with it to the town brothel where he gave it to a prostitute. Next morning the police escorted him to the local hospital. Gauguin departed shortly afterward, and his absence left van Gogh feeling very much alone; his two paintings of their empty chairs (*Van Gogh's Chair* and *Gauguin's Chair*, 1888) express the emptiness and isolation he experienced.

After his return from hospital, van Gogh was plagued with another breakdown and a persecution mania which could only have been exacerbated by news of Theo's forthcoming marriage which van Gogh feared would precipitate the loss of his closest friend and supporter. By now the inhabitants of Arles had become increasingly concerned about Vincent's eccentric behavior, so they petitioned the mayor and had the artist interned in the hospital. Despite his ill

health, he continued to paint (*The Hospital at Arles* and *Courtyard at the Hospital*, 1889), but as his breakdowns became more frequent, he voluntarily committed himself to an asylum at St-Rémy.

It must have been a very broken and dejected van Gogh who at the age of 36 entered the St-Paul-de-Mausole asylum at St-Rémy, near Arles in May 1889. His treatment by the inhabitants of Arles, the destruction of his dreams of a 'school of the south', and Theo's approaching wedding must have left him with a sense of total abandonment. He was diagnosed as suffering from epilepsy, but many theories have since emerged about the cause of his emotional instability, and it has been suggested that his mental illness was probably hereditary. Patients at the asylum did not receive any specific treatment, but despite spending many hours confined to his room he was eventually allowed to leave the asylum if accompanied. The landscape around St-Rémy gave him much new inspiration, and he painted the hospital garden, surrounding cornfields, olive groves, and cypress trees. One of his first paintings at St-Rémy was of the *Irises* (1889) in the hospital garden; the deep blues and lush greens show his continuing fascination with nature.

The St-Rémy period saw a distinct change in van Gogh's style; color was still important but no longer the predominant force; equal weighting was given to form and movement with many paintings containing winding and undulating contours. The tumultuous hills of *Ravine* (1889) show a tortuous, struggling

landscape, and cypresses became an important new motif; *A Cornfield with Cypresses* (1889) depicts a wildly flaming cypress against a turbulent background. In both these paintings van Gogh moved away from the bold complementary contrasts of previous works, and the colors are more muted and blend together as form took over as his means of expression.

During a mental breakdown, which was often unpredictable, van Gogh had a tendency to become violent and have terrible hallucinations. Although much has been written about how van Gogh's change in style was linked to his illness, as he never painted during an attack the transformation was probably more likely a simple change of direction rather than an indication of the artist's state of mind. In July he suffered a severe attack which lasted several months, after which he painted his last *Self-Portrait* (1889); the soft blue-green tones and swirling, wavy brushstrokes provide a startling contrast to van Gogh's transfixing, uneasy stare.

At the end of 1889, both bad weather and an increase in the frequency of his breakdowns caused van Gogh's inspiration to decline somewhat. He made many copies of his own work and old masters he admired like Millet (*Noon or the Siesta*, 1890) and Delacroix (*Pietà*, 1889). Biblical themes figured prominently in his painting as once again his thoughts returned to religion. Van Gogh reached an extremely low point at Christmas, when he tried to commit suicide during an attack, but hopeful times were on the horizon. His spirits were lifted with news of the

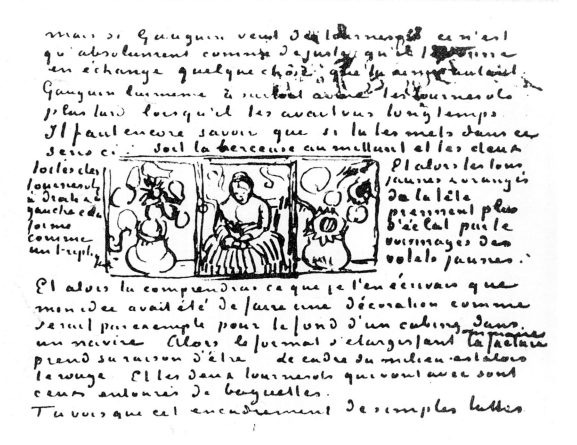

LEFT AND BELOW: Sketches from two of van Gogh's letters. The lower pictures are rough outlines of sunflowers.

birth of Theo's son, who was named after Vincent. The proud uncle painted *Branches of an Almond Tree* (1890), a springtime scene with a radiant blue sky, for his nephew. At the same time more good news reached him of a favorable article written about him in an art magazine, *Mercure de France*. His spirits were further bolstered by the sale of *The Red Vineyard* for 400 Belgian francs.

Since November he had written to Theo of how he longed for the north and to be near his family again. After suffering a further attack of derangement and hallucinations which lasted almost two months, he came to the decision that staying at St-Rémy was pointless. In May 1890, Theo arranged for him to stay at Auvers-sur-Oise, a small village outside Paris, with Dr Paul Gachet – a friend of several Impressionists

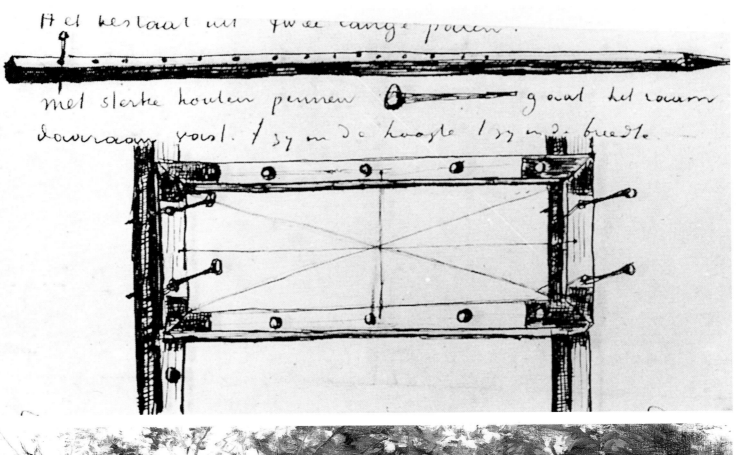

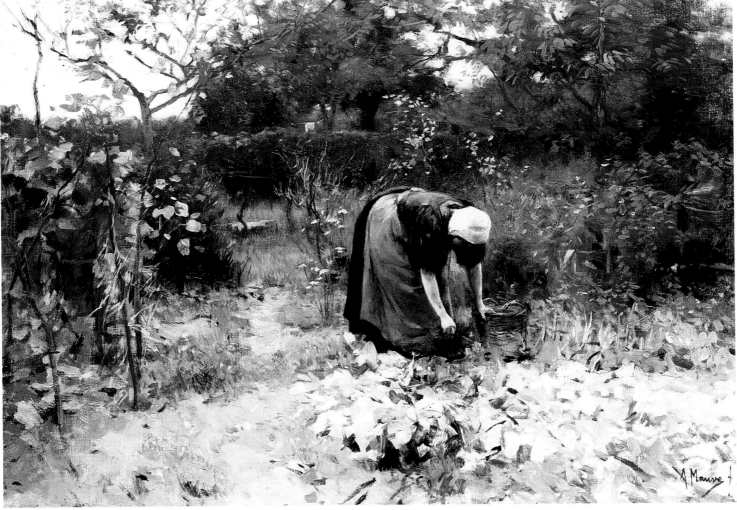

TOP: Van Gogh's perspective frame.

ABOVE: *In the Vegetable Garden* by Anton Mauve, 1886/7.

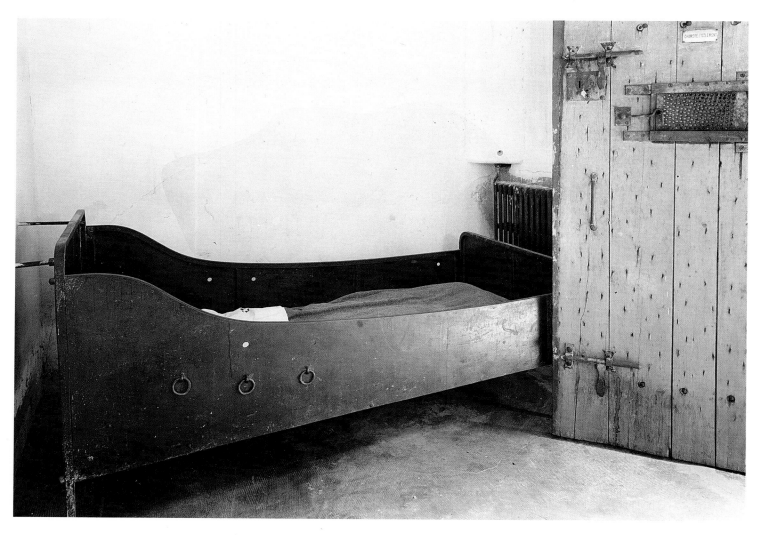

M⁏

Monsieur Th. van Gogh et toute sa Famille ont la douleur de vous faire part de la perte qu'ils viennent de faire en la personne de Monsieur

Vincent Willem van Gogh

ARTISTE PEINTRE

décédé, à l'âge de 37 ans, le 29 Juillet 1890, à Auvers-sur-Oise.

PARIS, 8, CITÉ PIGALLE
LEYDE, HEERENGRACHT (HOLLANDE)

LEFT: The announcement of Vincent's death, sent to friends by his mother.

and a keen artist. Van Gogh became close friends with Dr Gachet and began painting with great fervor, producing numerous pictures of Auvers (*Thatched Cottages at Cordeville* and *The Church at Auvers*, 1890). Now that he was away from the asylum, he could concentrate once more on portraits, and in his painting *Dr Paul Gachet* (1890), like many other works from Auvers, vigorous brushstrokes create a sloping and wavering effect.

By July van Gogh had become more unbalanced, Theo was having financial difficulties and suffering from ill health and Dr Gachet was away, which all

contributed to the painter's building anxiety. One of his last paintings *Crows Over a Cornfield* (1890) — seen by many critics as an omen of his impending suicide — shows an ominously thunderous sky, with crows circling like vultures over a wide, lonely expanse of field. On 27 July the artist walked into the fields, shot himself in the chest and dragged himself back to his lodgings, where he died two days later with his brother Theo by his side.

Although not recognized during his lifetime, many years after his death van Gogh became a major influence on post-Impressionist art and the Expressionist movement of the 20th century. Van Gogh's sad and turbulent life has become almost a legend — inspiring countless books, many theories about his psychological state, and even some films. Van Gogh, who always hoped his paintings would appeal to a wide audience, would have been pleased with this posthumous attention. As he foretold in a letter to Theo: 'I cannot help it that my paintings do not sell. Nevertheless the time will come when people will see that they are worth more than the price of the paint . . .'

TOP: Lucien Pisarro's study of van Gogh.

ABOVE: *Van Gogh on his Deathbed* by Dr Gachet.

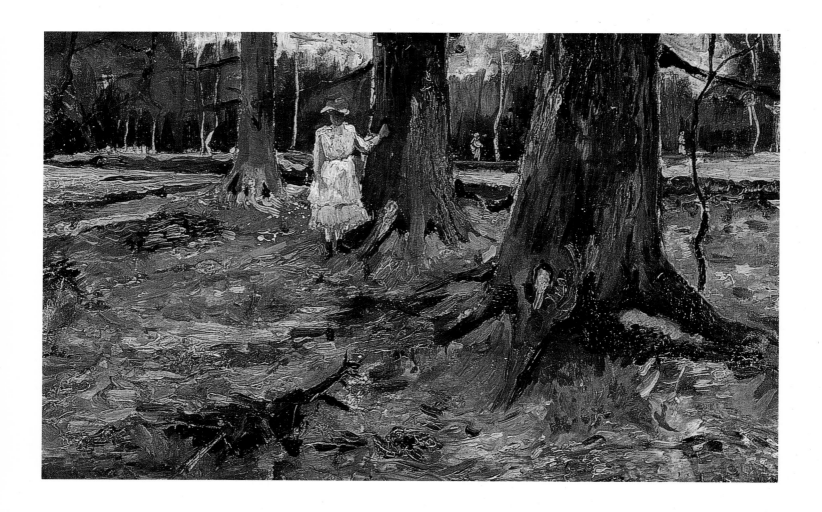

Girl Under Trees late summer 1882
Oil on canvas, 14¼ x 23¼ in.
Collection State Museum Kröller-Müller,
Otterlo, The Netherlands

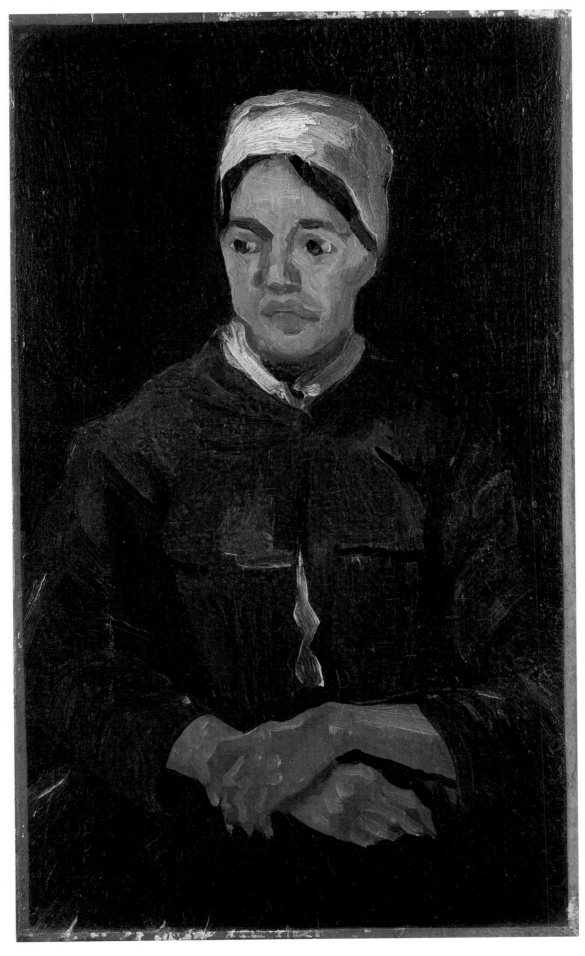

Peasant Woman from Nuenen 1885
Oil on canvas, 17¾ x 10½ in.
Christie's Images,
London

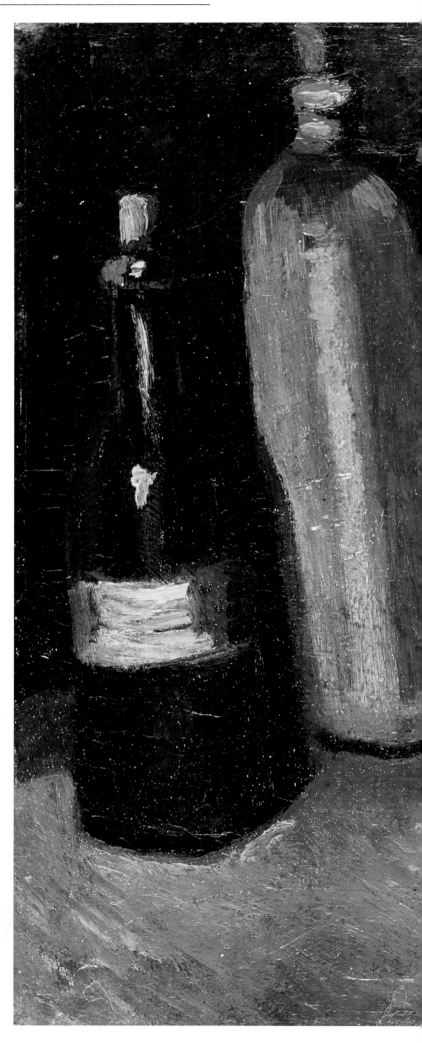

**Still Life with Four Stone Bottles, Flask
and White Cup** November 1884-March 1885
Oil on canvas, 13 x 16⅛ in.
Collection State Museum Kröller-Müller,
Otterlo, The Netherlands

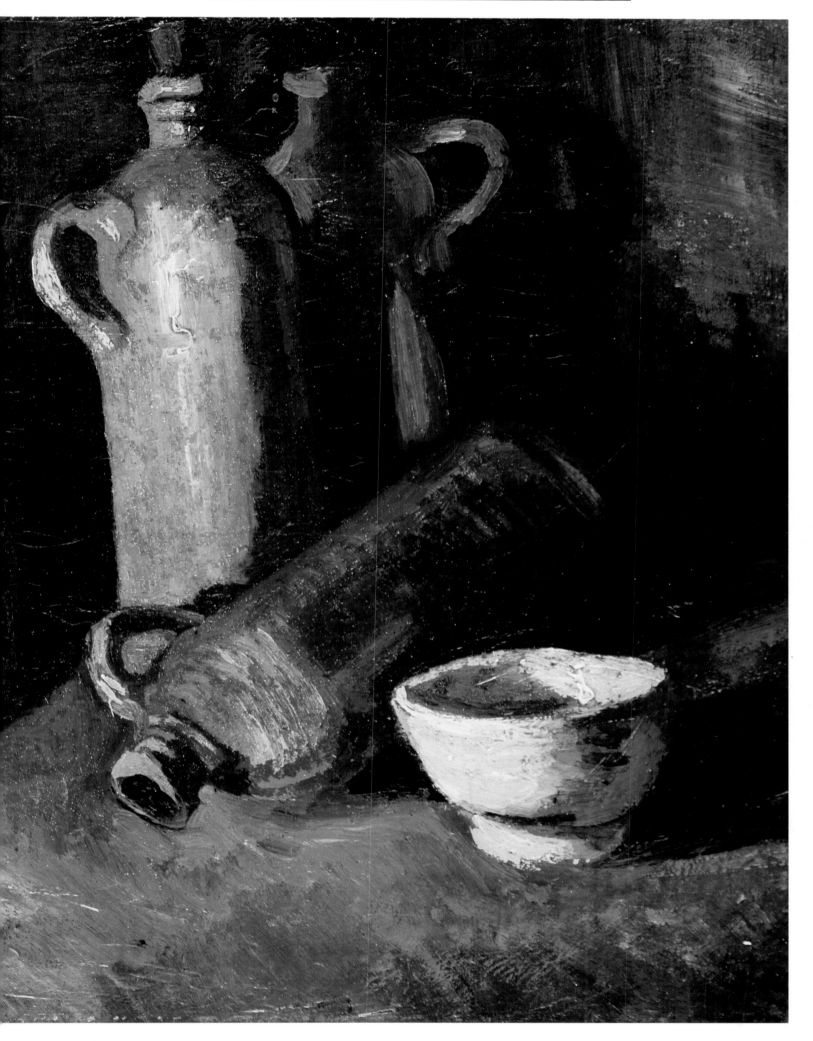

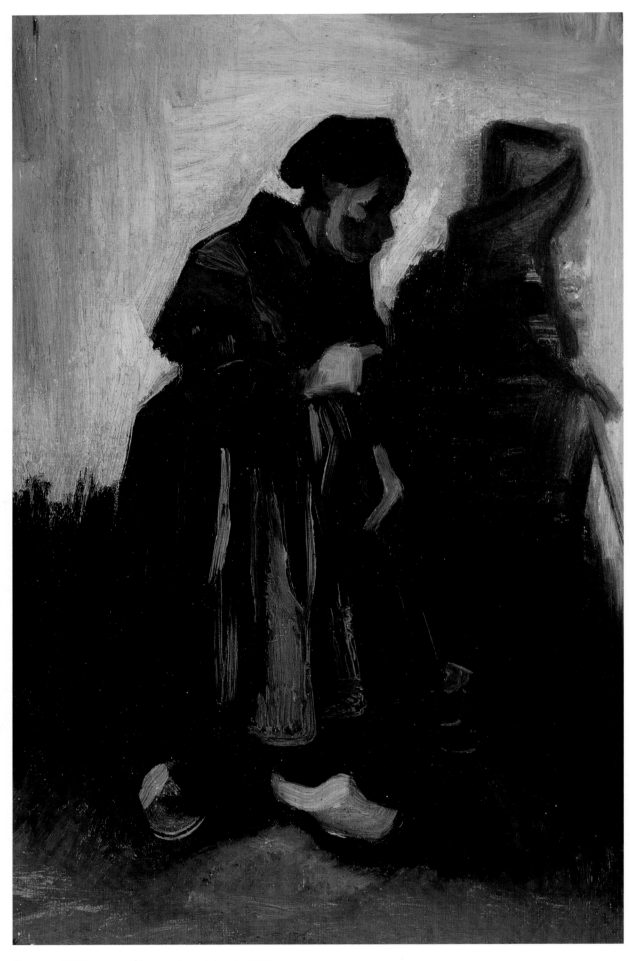

Peasant Woman Sweeping March 1885
Canvas mounted on panel, 16¼ x 10⅝ in.
Collection State Museum Kröller-Müller,
Otterlo, The Netherlands

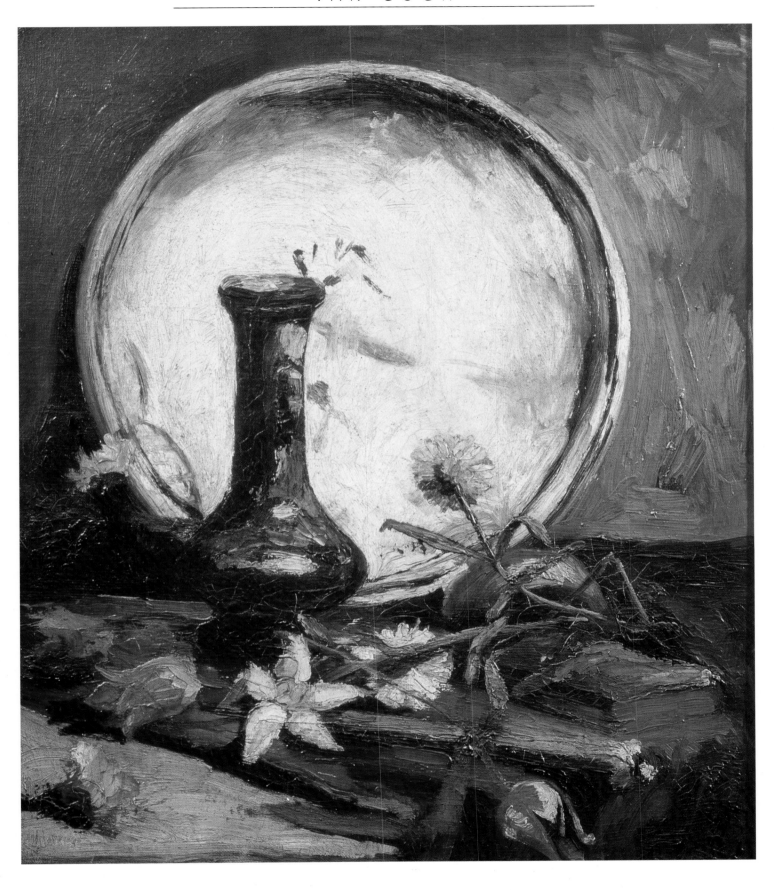

Still Life with Flowers c. 1886
Oil on canvas, 21¼ x 17¾ in.
Giraudon/Bridgeman Art Library, London

31

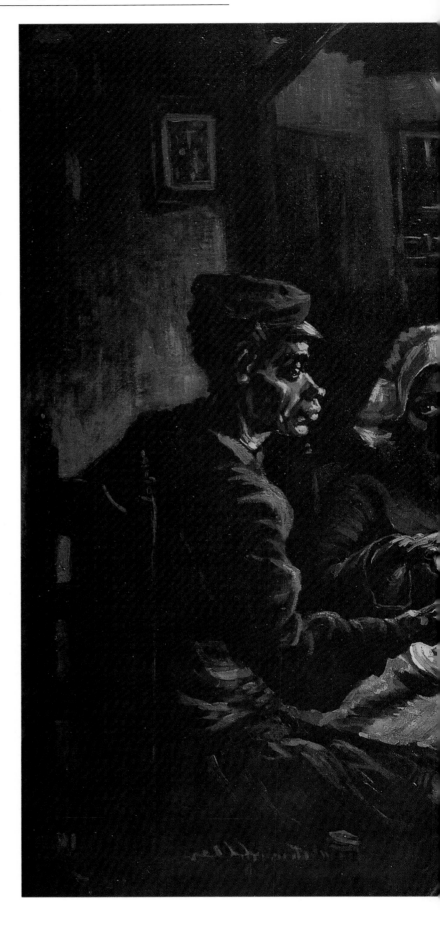

The Potato Eaters April-May 1885
Oil on canvas 32¼ x 45 in.
Rijksmuseum Vincent van Gogh,
Amsterdam

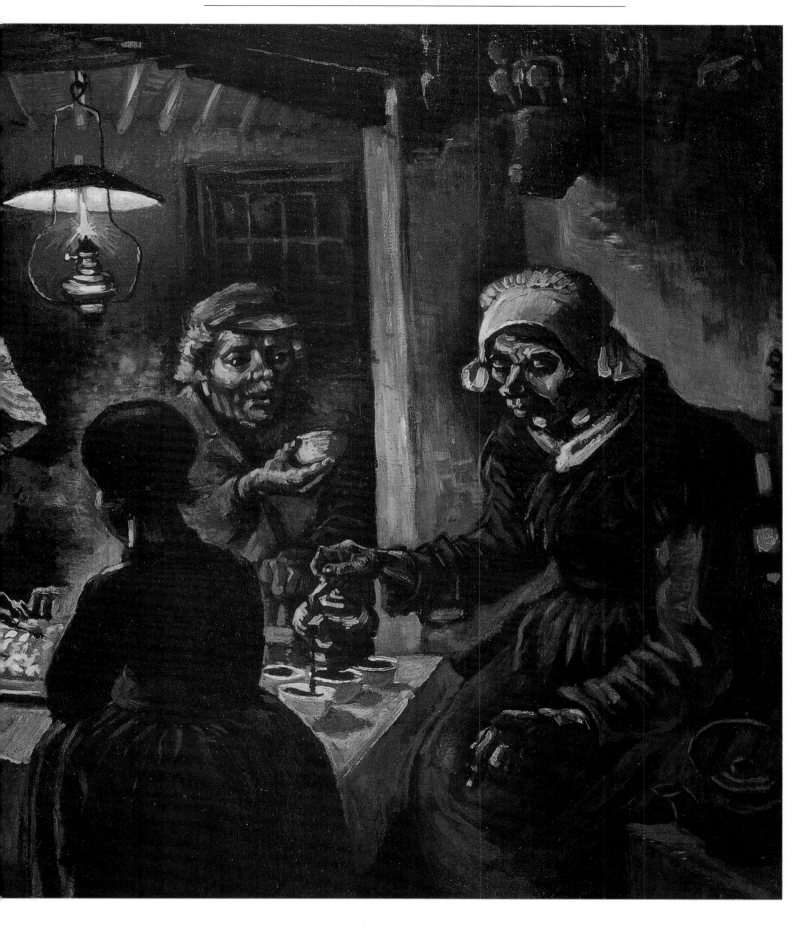

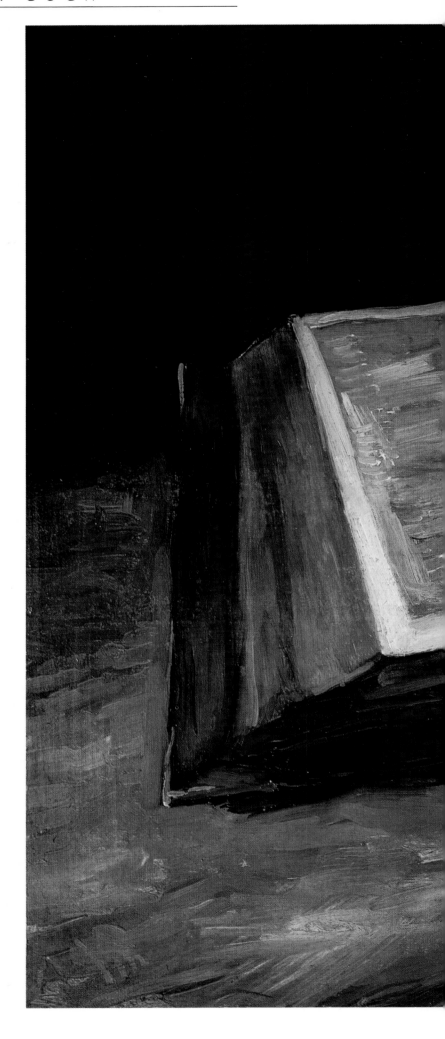

**Still Life with Open Bible, Extinguished Candle,
and Zola's 'Joie de Vivre'** October 1885
Oil on canvas, 25½ x 30¾ in.
Rijksmuseum Vincent van Gogh,
Amsterdam

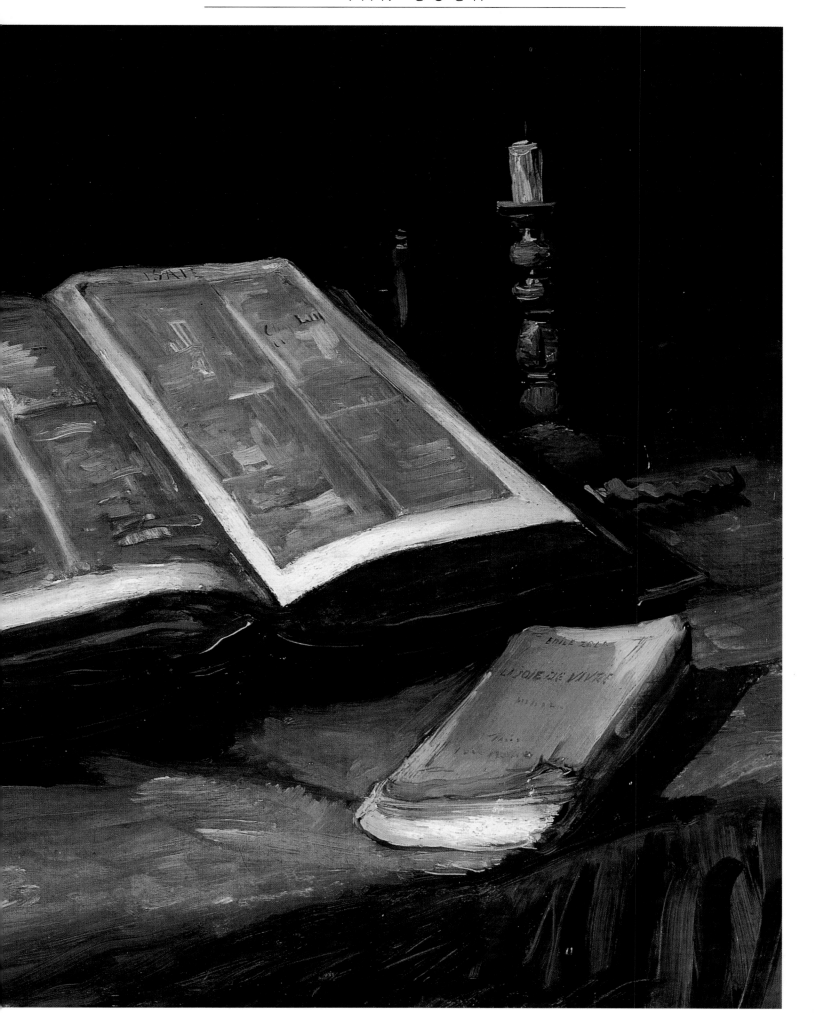

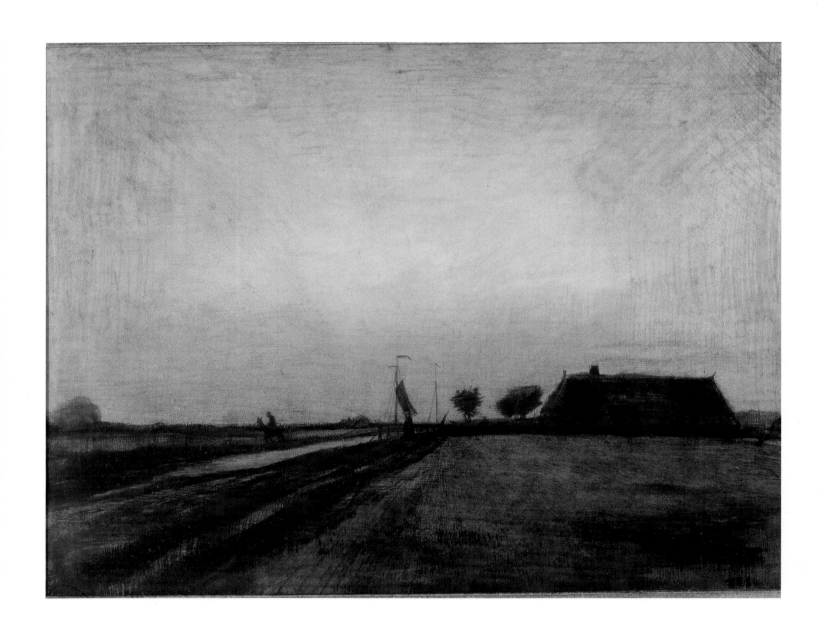

La Levée du Soleil 1883
Oil on canvas, 12¹⁄₁₆ x 16¼.
Christie's Images,
London

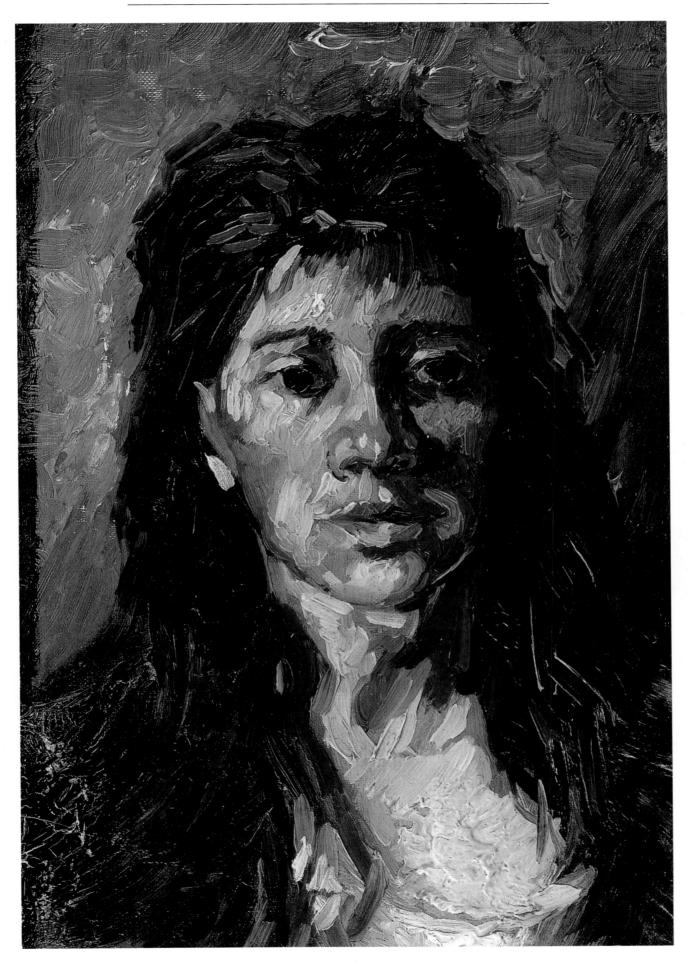

Head of a Woman December 1885
Oil on canvas, 13¼ x 9½ in.
Rijksmuseum Vincent van Gogh,
Amsterdam

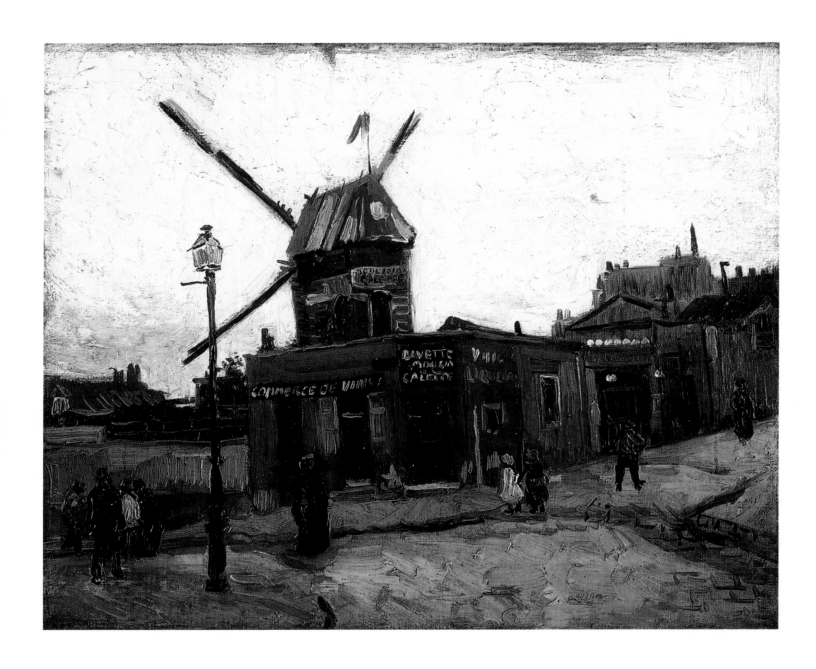

Le Moulin de la Galette October 1886
Oil on canvas, 15 x 18 in.
Collection State Museum Kröller-Müller,
Otterlo, The Netherlands

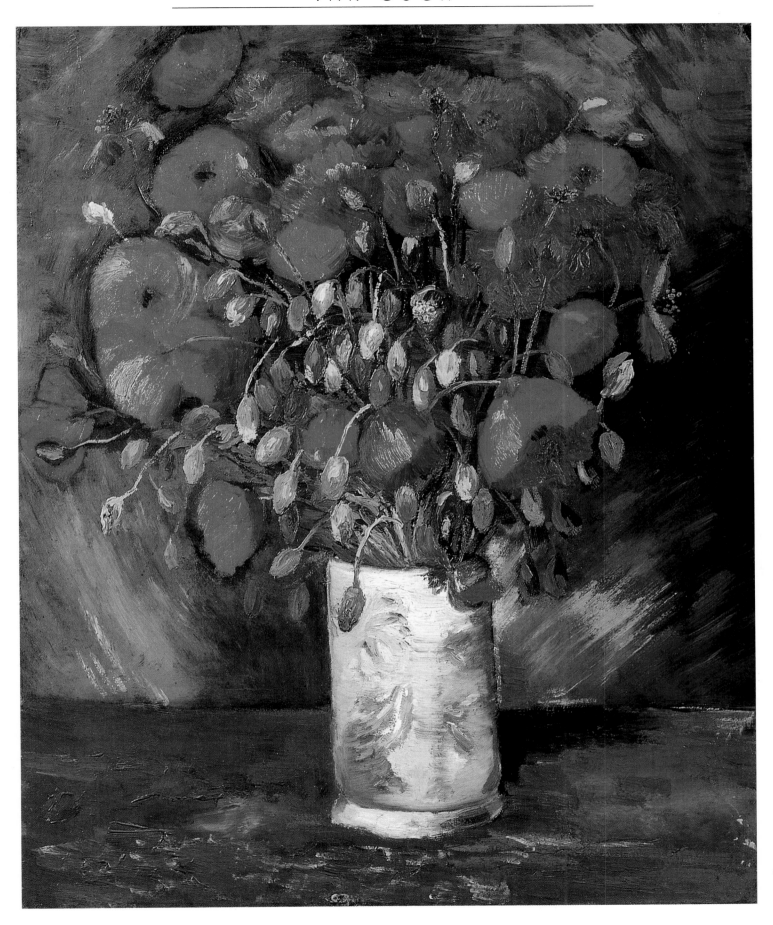

Poppies May 1886
Oil on canvas, 21½ x 17¾ in.
Wadsworth Atheneum, Hartford,
CT, USA
Bequest of Anne Parrish Titzell

Romans Parisiens (Les Livres Jaunes)
Oil on canvas 29 x 36½ in.
Christie's Images,
London

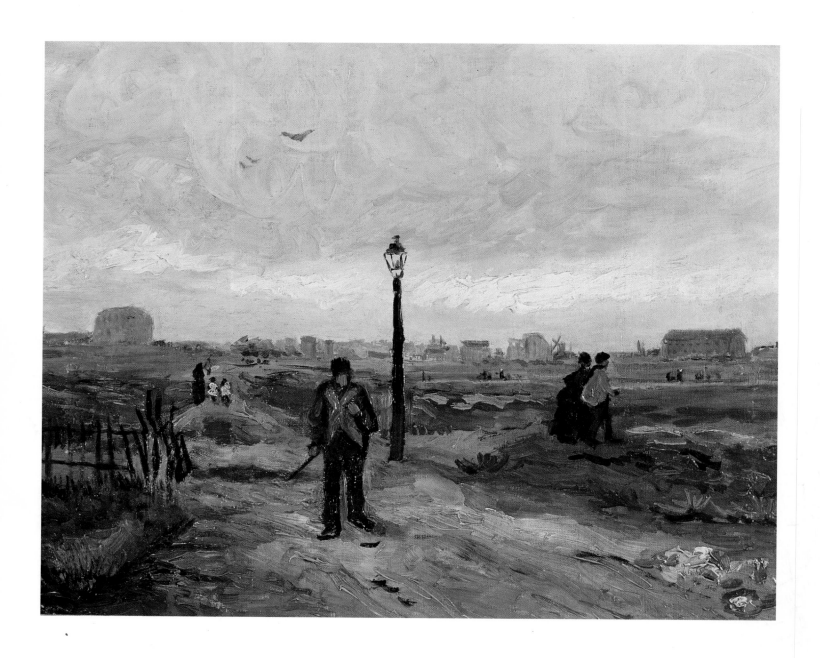

The Outskirts of Paris 1886
Oil on cardboard, 18 x 21½ in.
Christie's Images, London/Bridgeman Art Library, London

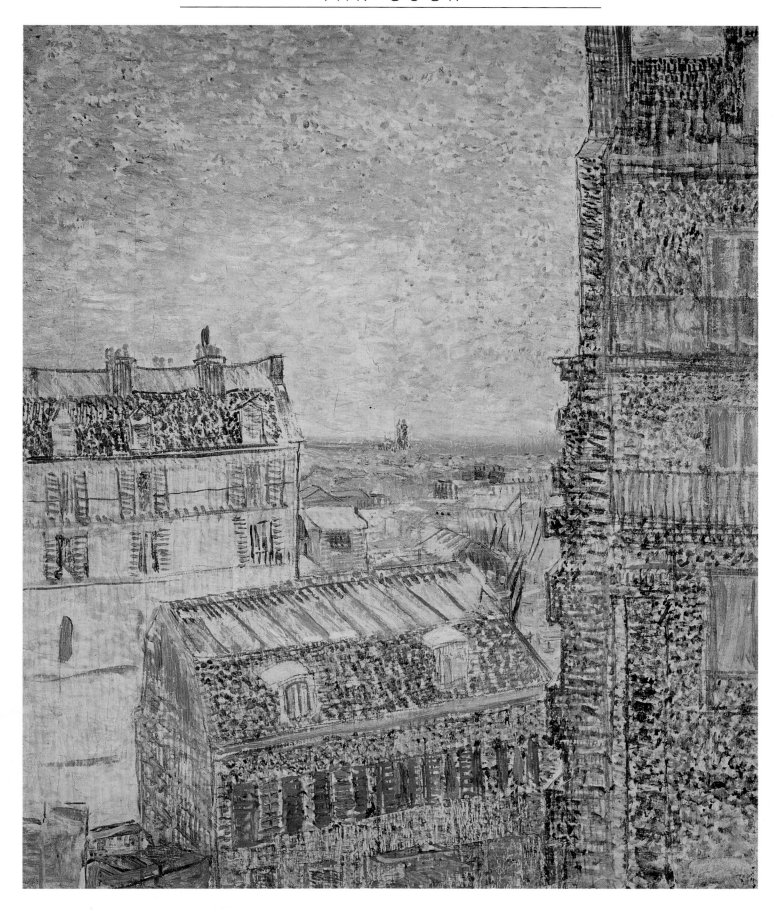

View from Van Gogh's Room, Rue Lepic, Paris Spring 1887
Oil on canvas, 18 x 15 in.
Rijksmuseum Vincent van Gogh,
Amsterdam

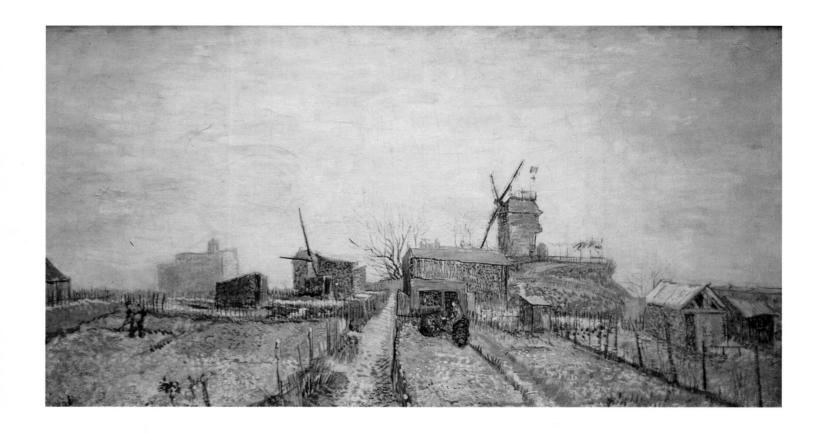

The Allotments at Montmartre 1887
Oil on canvas, 17⅜ x 31⁹⁄₁₀ in.
Rijksmuseum, Vincent van Gogh,
Amsterdam/Bridgeman Art Library, London

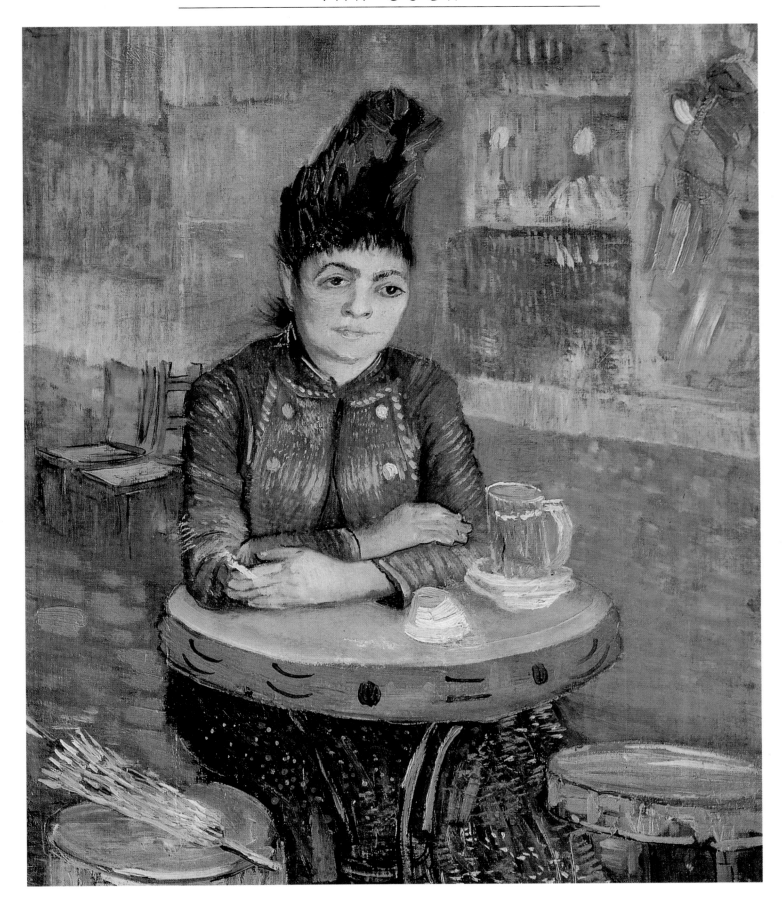

Woman at the Café du Tambourin (Agostina Segatori)
Spring 1887
Oil on canvas, 21¾ x 18¼ in.
Rijksmuseum Vincent van Gogh,
Amsterdam

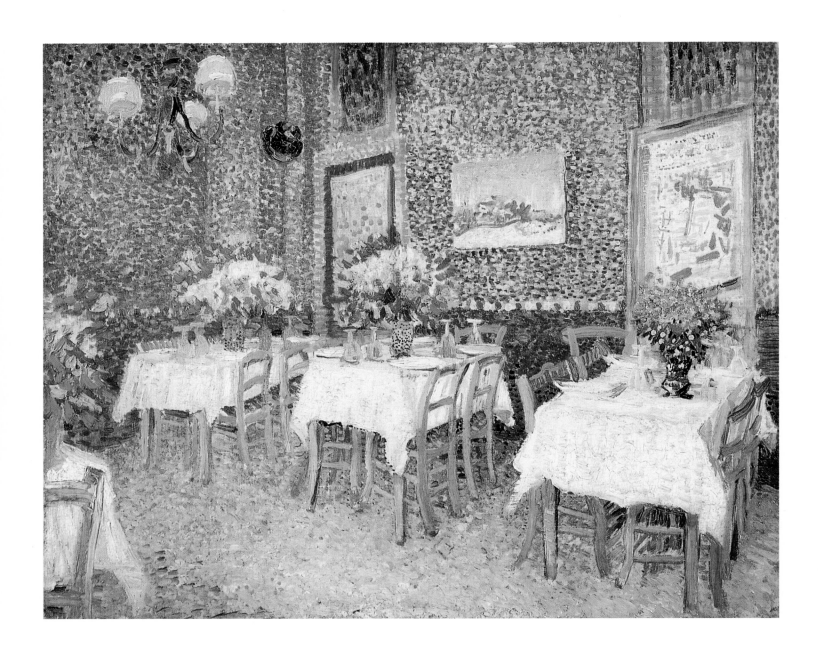

Interior of a Restaurant Summer 1887
Oil on canvas, 17¾ x 22 in.
Collection State Museum Kröller-Müller,
Otterlo, The Netherlands

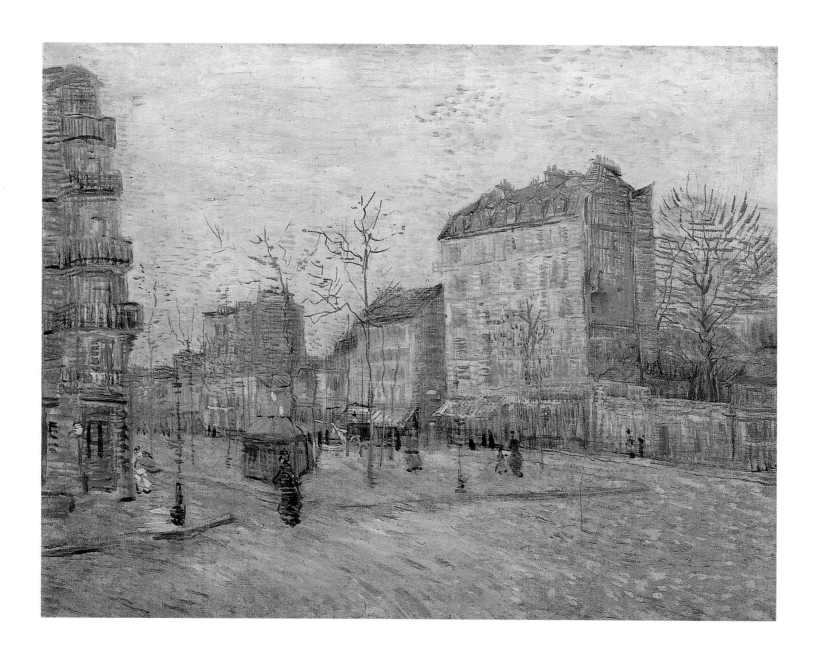

The Boulevard de Clichy February/March 1887
Oil on canvas, 18 x 21½ in.
Rijksmuseum Vincent van Gogh,
Amsterdam

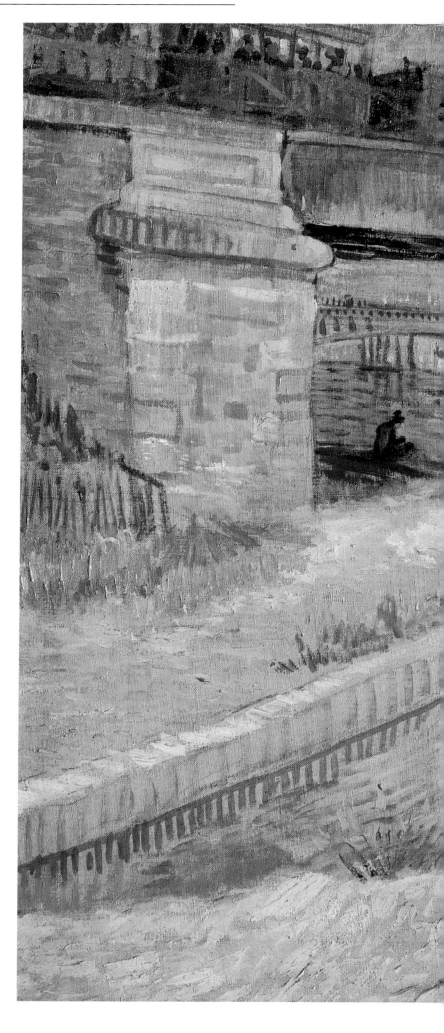

Bridge at Asnières, July-September 1887
Oil on canvas 20½ x 25½ in.
Foundation E G Bührle,
Zurich

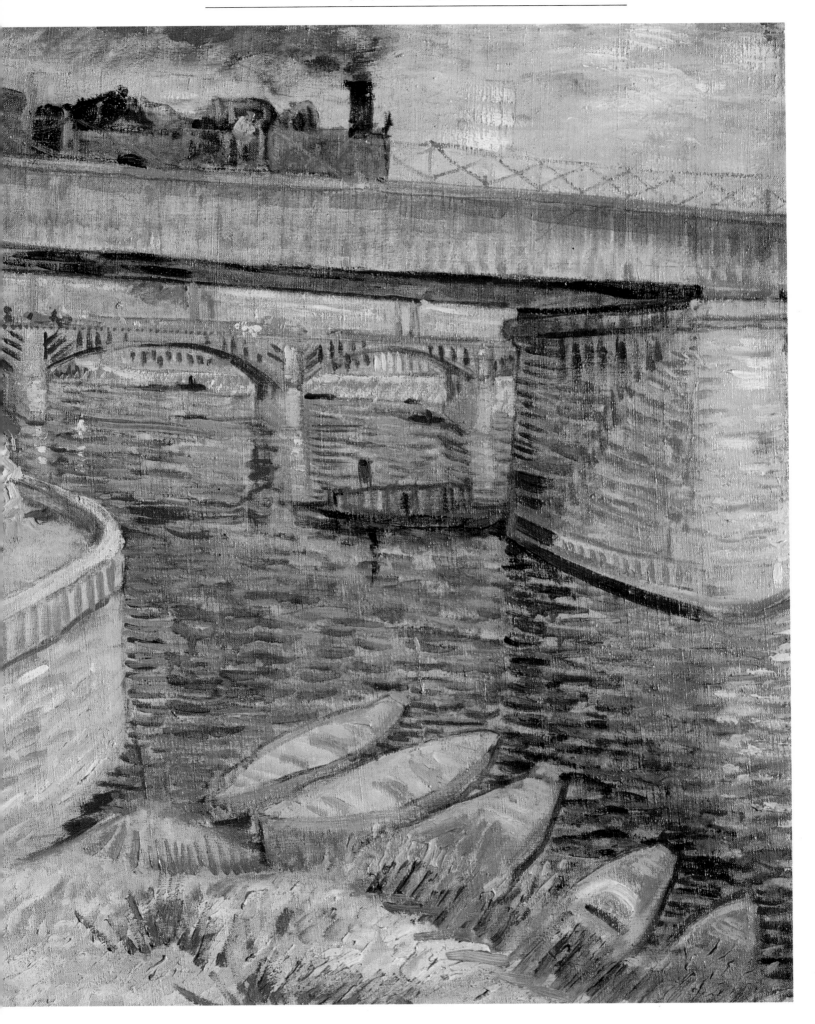

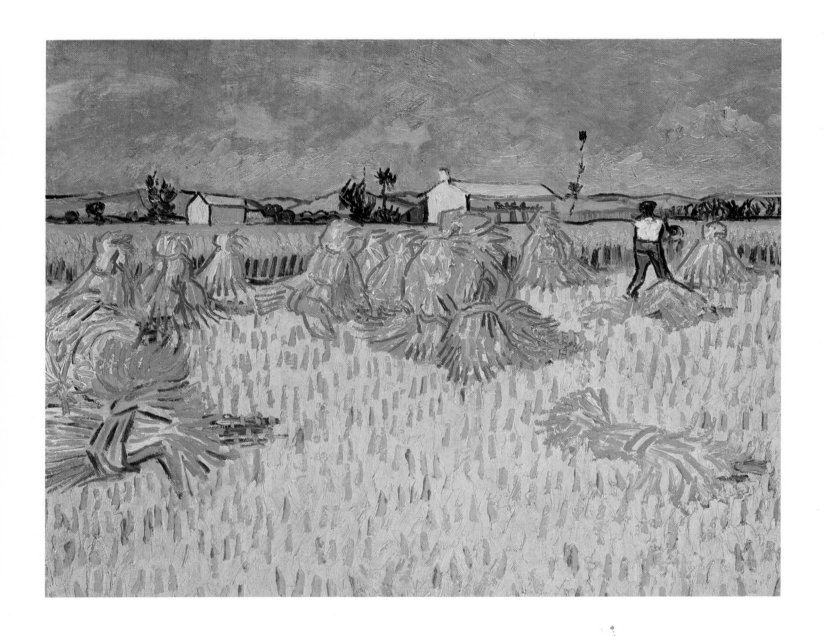

Wheatfield with Sheaves 1888
Oil on canvas, 19⁷⁄₁₀ x 23⅜ in.
Israel Museum, Jerusalem/Bridgeman Art Library, London

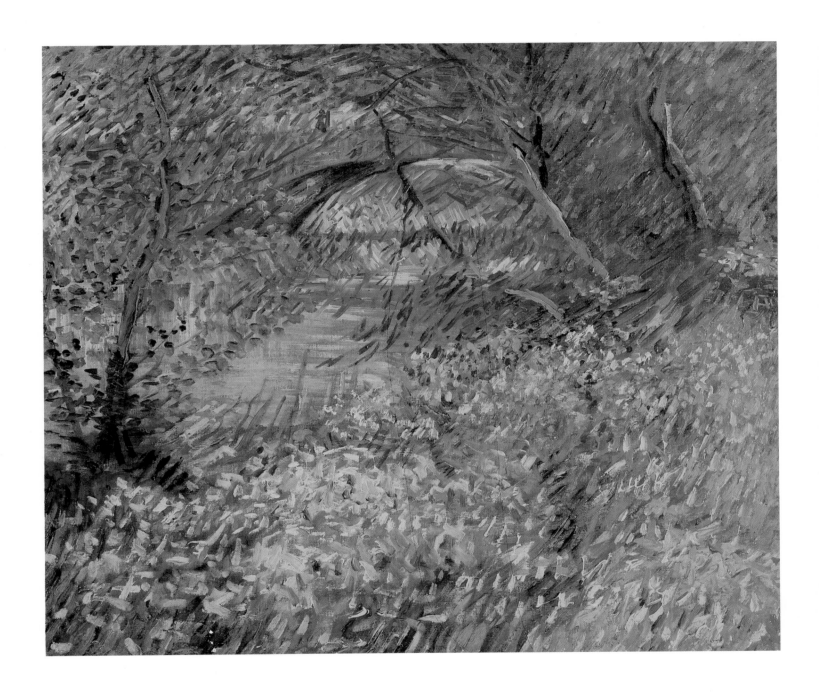

Riverbank in Springtime Summer 1887
Oil on canvas, 19 x 22½ in.
Dallas Museum of Art,
The Eugene and Margaret McDermott Fund in memory of Arthur Berger

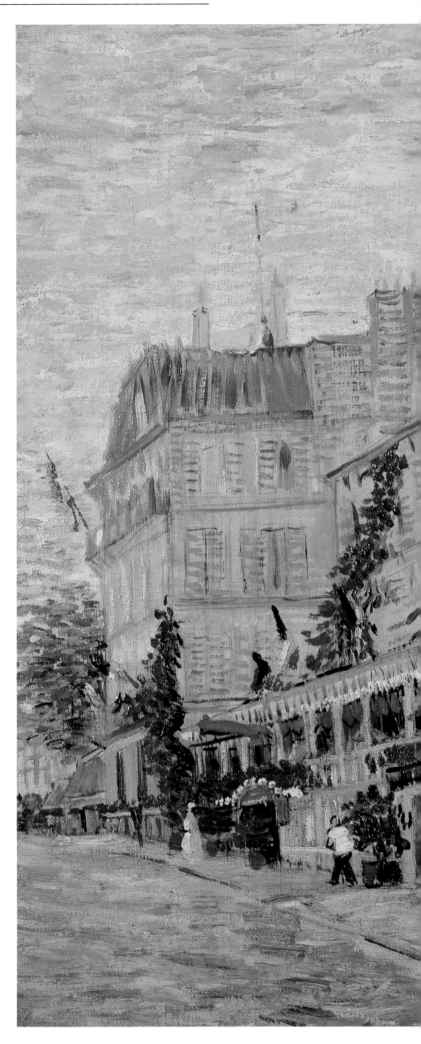

Restaurant de la Sirene, Asnières, 1887
Oil on canvas 21 x 25⅝ in.
Musée d'Orsay,
Paris

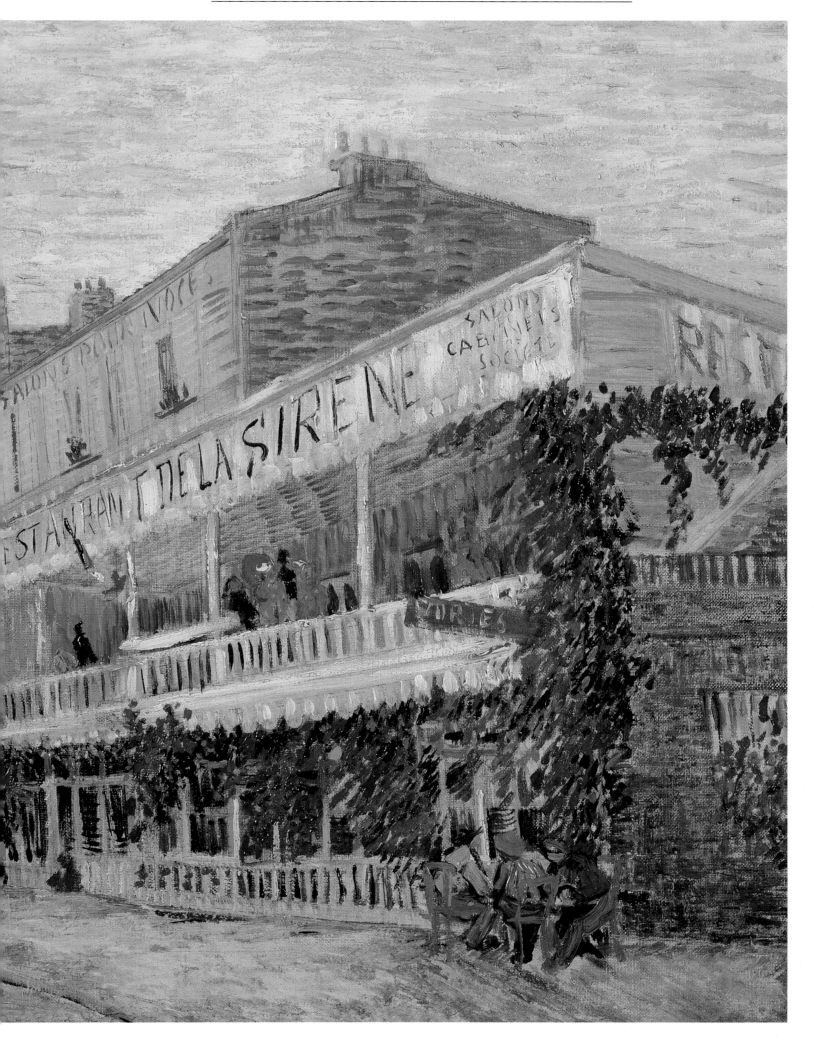

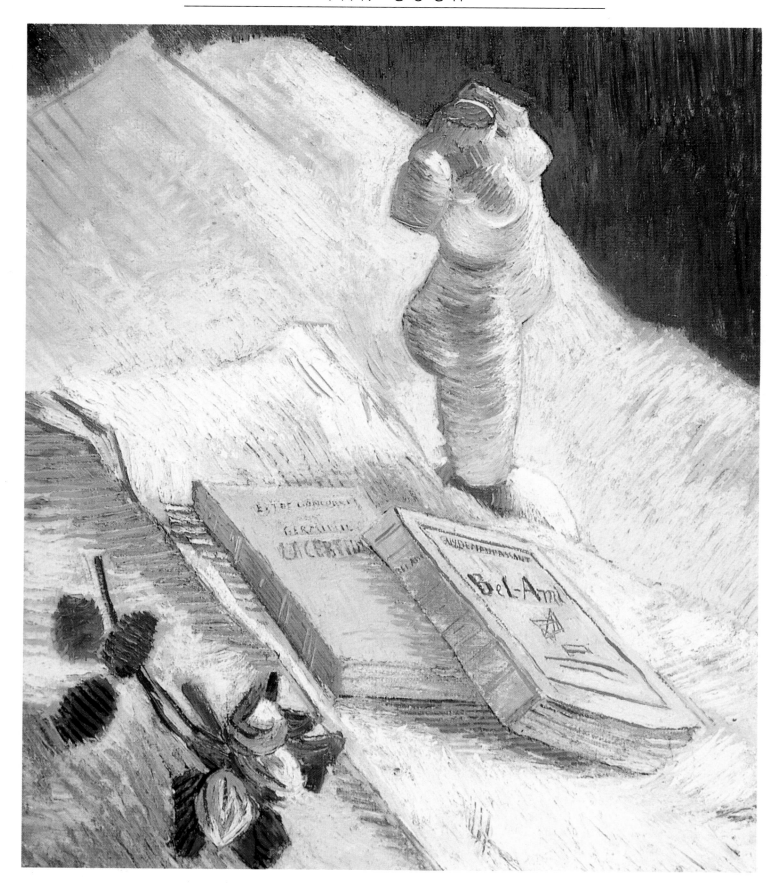

Still Life with Plaster Statuette and Two Novels Autumn 1887
Oil on canvas, 21¾ x 18¼ in.
Collection State Museum Kröller-Müller,
Otterlo, The Netherlands

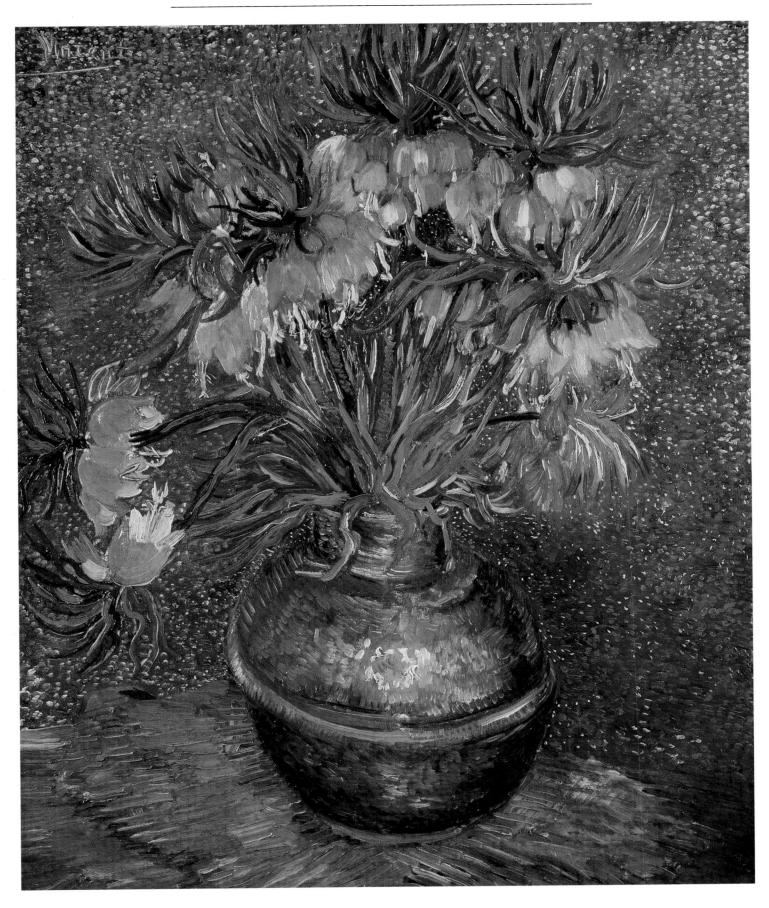

Fritillaries in Copper Vase 1886
Oil on canvas, 29 x 23¾ in.
Musée d'Orsay,
Paris

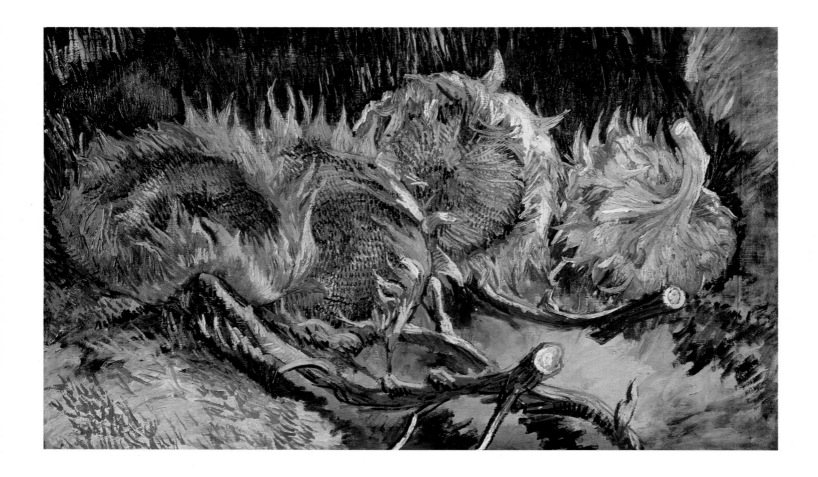

Four Withered Sunflowers, 1887
Oil on canvas, 23⅜ x 39⅝ in.
Collection State Museum Kröller-Müller,
Otterlo/Bridgeman Art Library, London

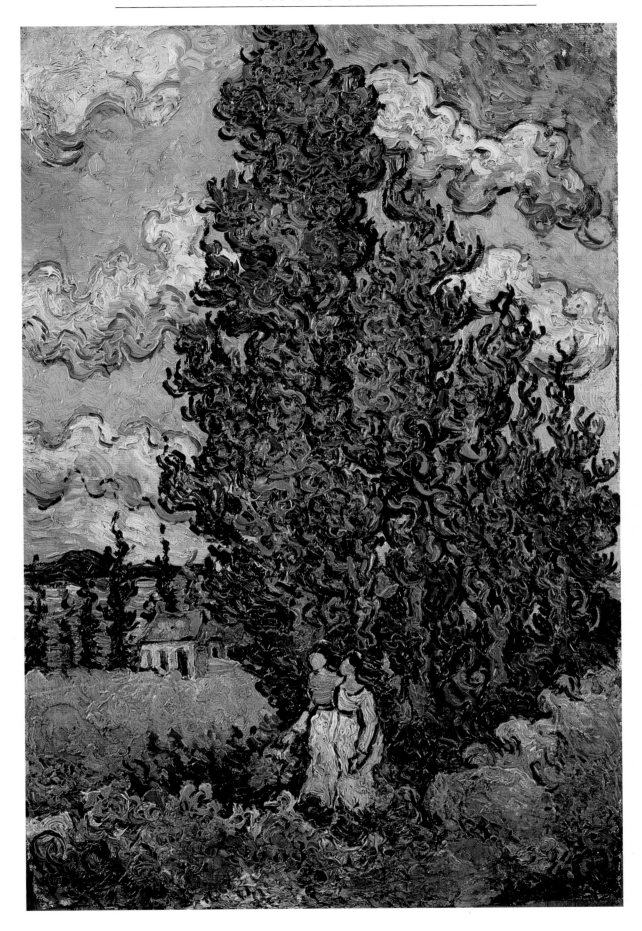

Cypresses and Two Women 1890
Oil on canvas, 36¼ x 28¾ in.
Rijksmuseum Vincent van Gogh,
Amsterdam

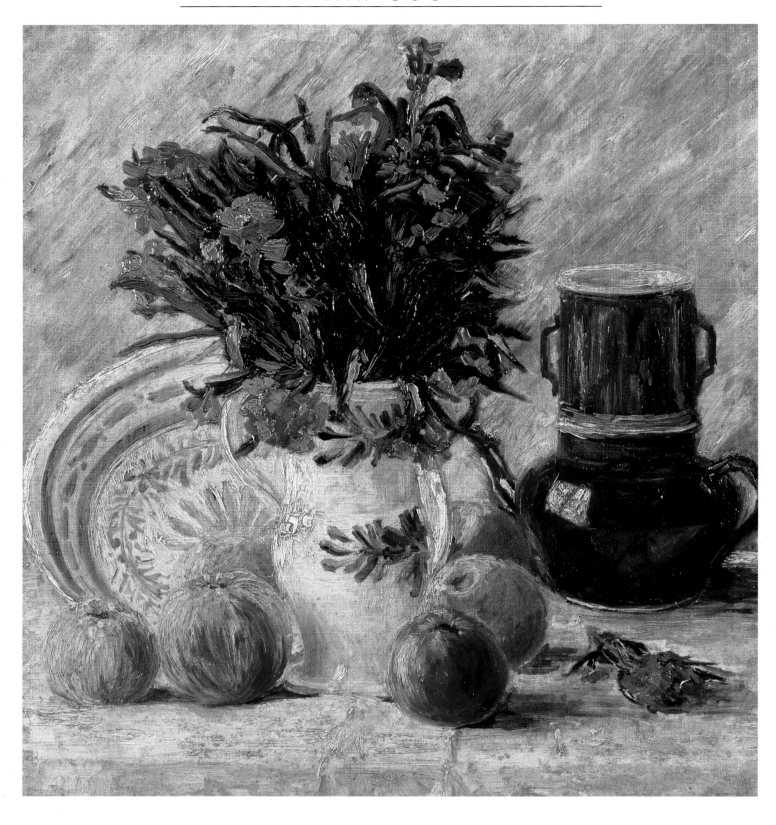

Vase of Flowers with a Coffee Pot and Fruit 1887
Oil on canvas, 16⅒ x 15 in.
Heydt Museum, Wuppertal, Germany/
Bridgeman Art Library, London

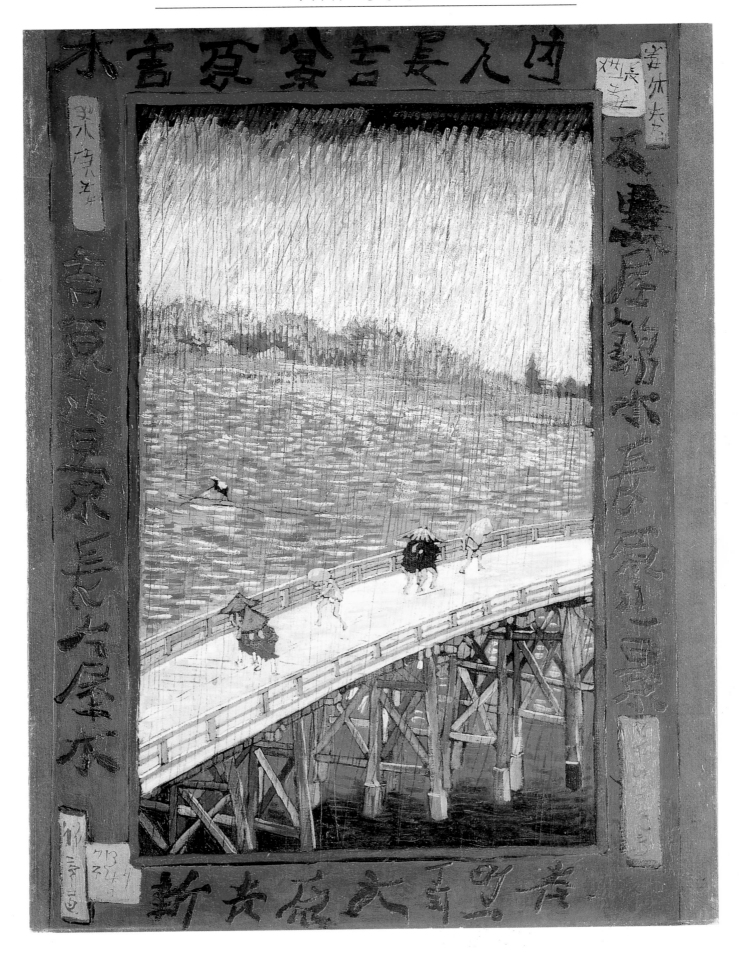

Japonaiserie — Bridge in the Rain (after Hiroshige) Late 1887
Oil on canvas, 28¾ x 21¼ in.
Rijksmuseum Vincent van Gogh,
Amsterdam

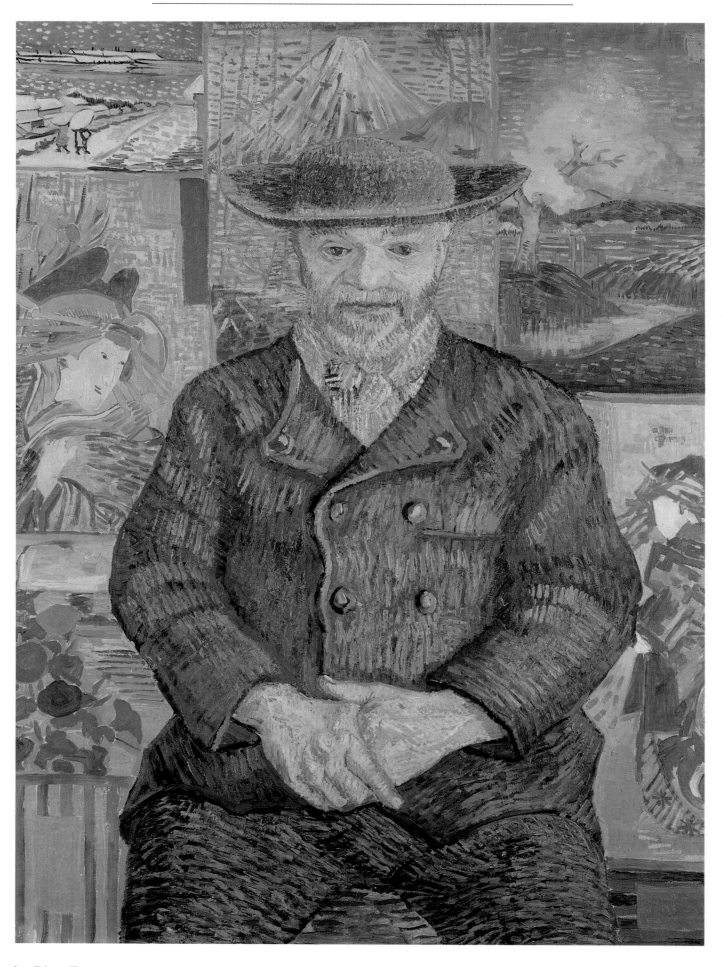

Le Père Tanguy Autumn 1887
Oil on canvas, 36¼ x 18¾ in.
Musée Rodin,
Paris

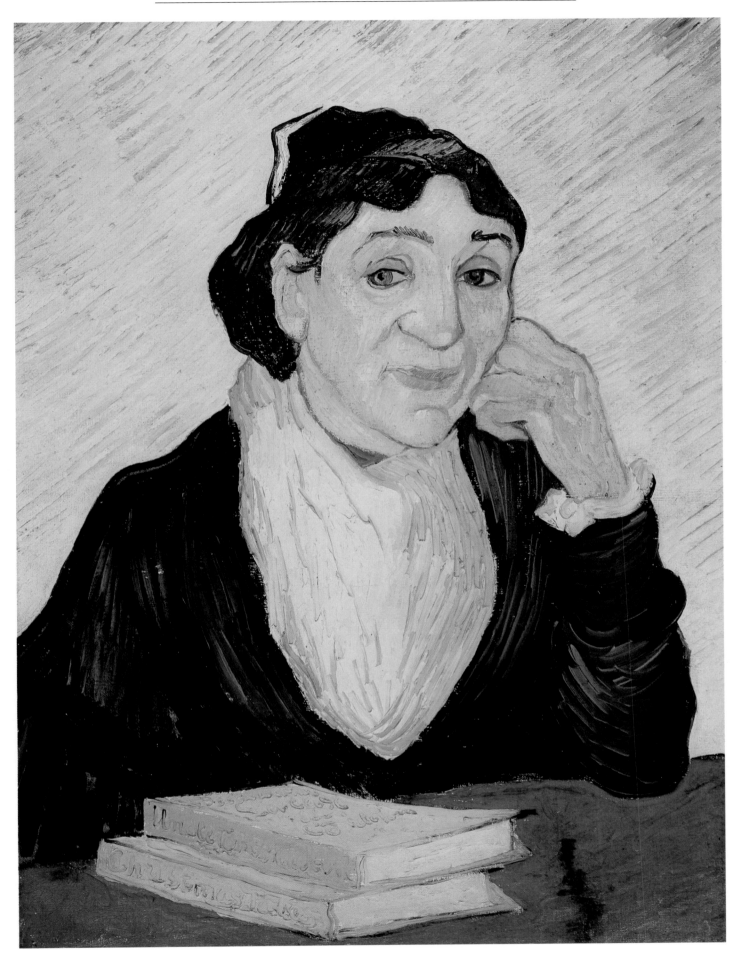

L'Arlésienne: Mme Ginoux January-February 1890
Oil on canvas, 25½ x 19¼ in.
Collection State Museum/Kröller-Müller,
Otterlo, The Netherlands

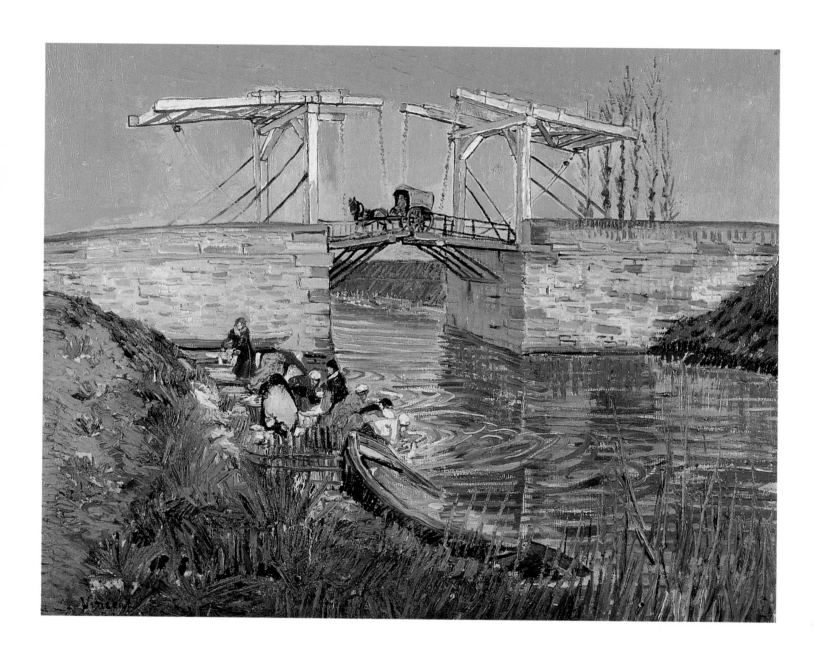

The Langlois Bridge with Women Washing March 1888
Oil on canvas, 21¼ x 25½ in.
Collection State Museum Kröller-Müller,
Otterlo, The Netherlands

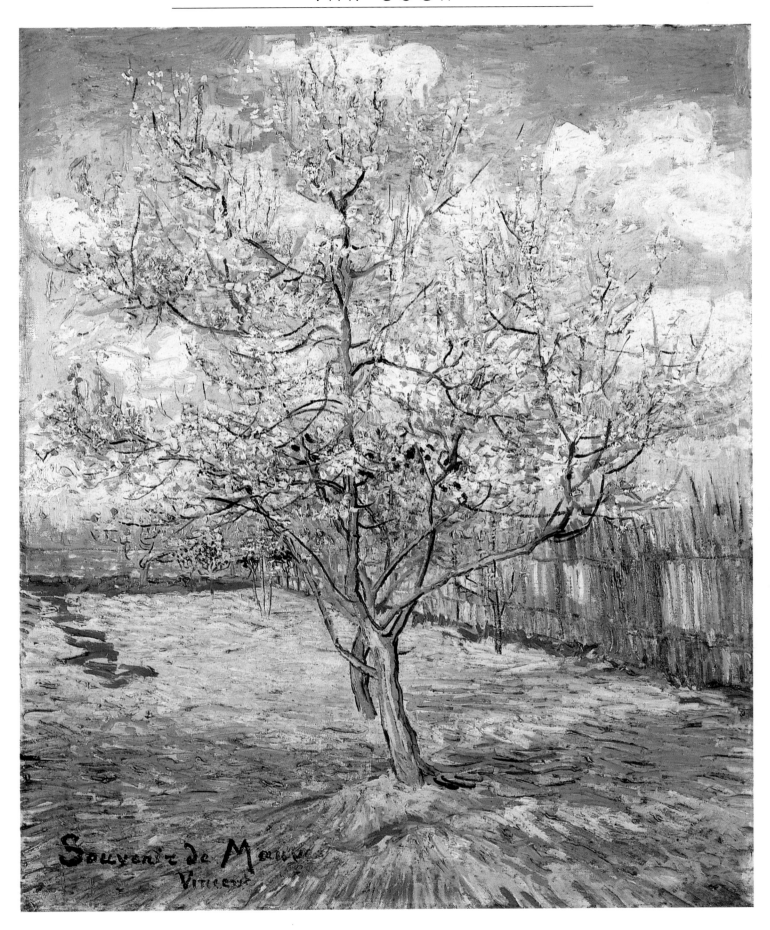

Pink Peach Tree in Blossom (In Memory of Mauve) March 1888
Oil on canvas, 28¾ x 23½ in.
Rijksmuseum Vincent van Gogh,
Amsterdam

The Sower 1888
Oil on canvas, 12½ x 15¾ in.
Private Collection/Bridgeman Art Library, London

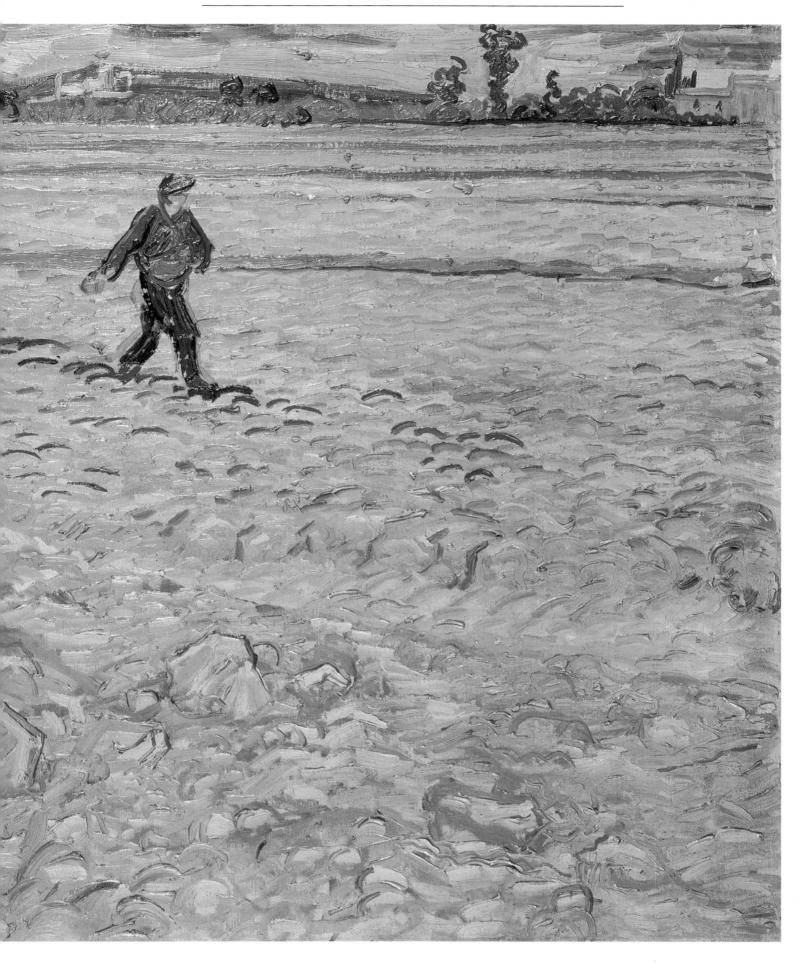

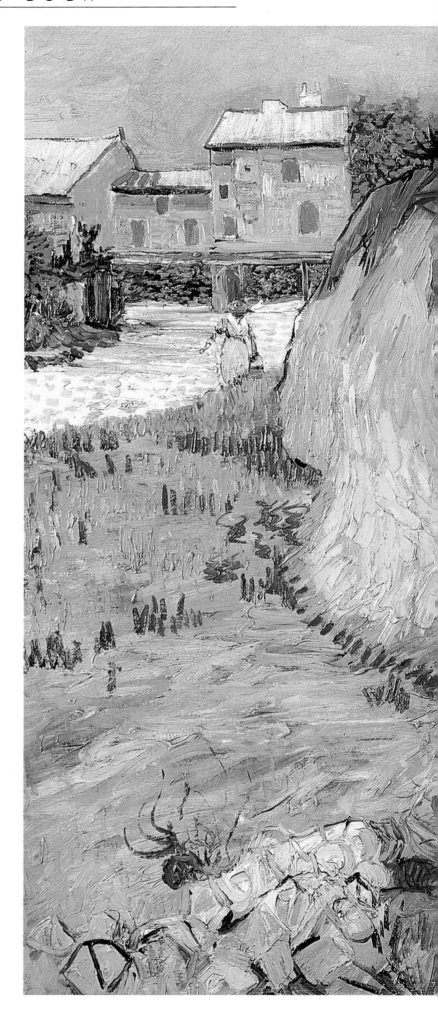

Haystacks in Provence June 1888
Oil on canvas, 28¾ x 36 in.
Collection State Museum Kröller-Müller,
Otterlo, The Netherlands

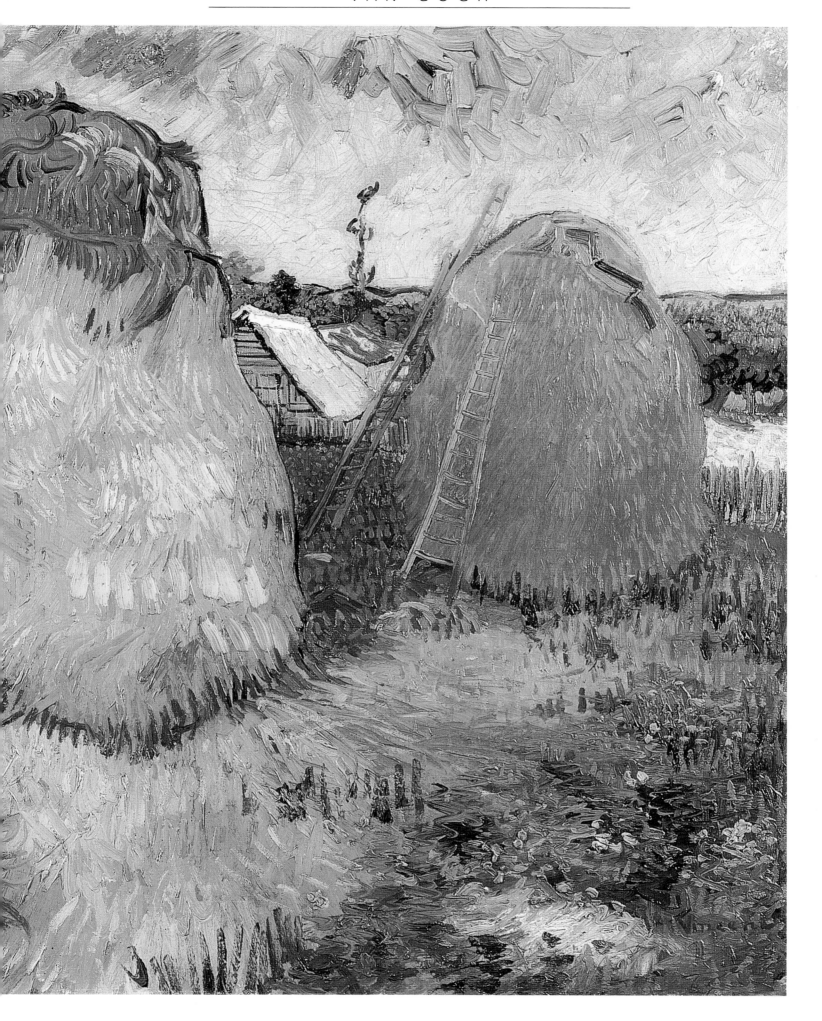

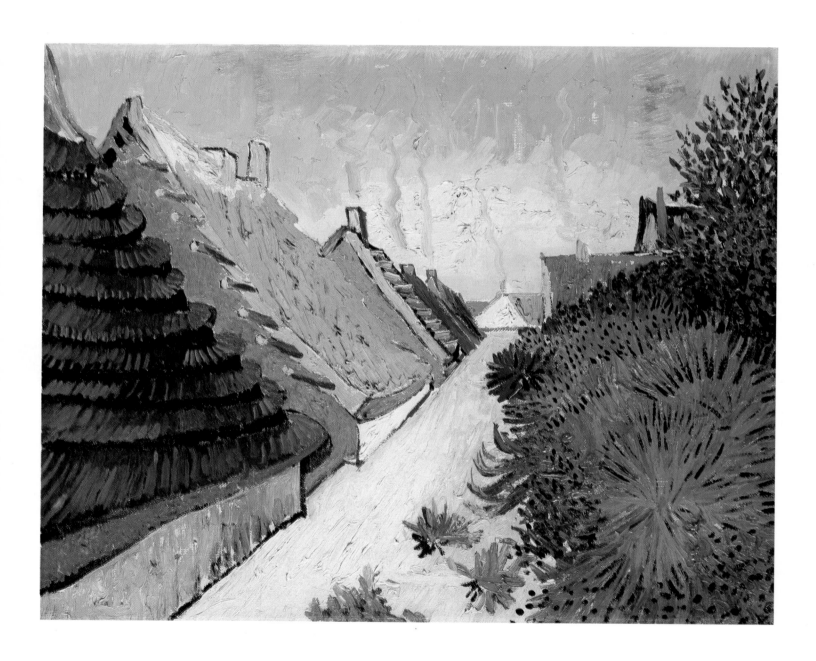

Mas at Saintes-Maries 1888
Oil on canvas, 15 x 18⅛ in.
Christie's Images, London/Bridgeman Art Library, London

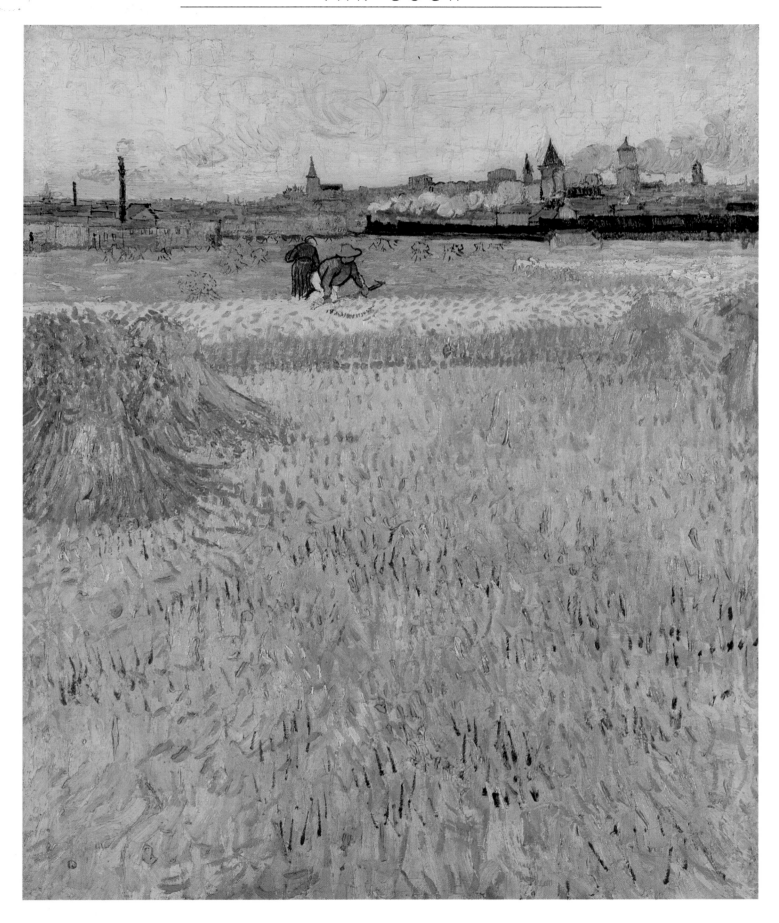

The Mowers, Arles in the Background June 1888
Oil on canvas, 28¾ x 21¼ in.
Musée Rodin,
Paris

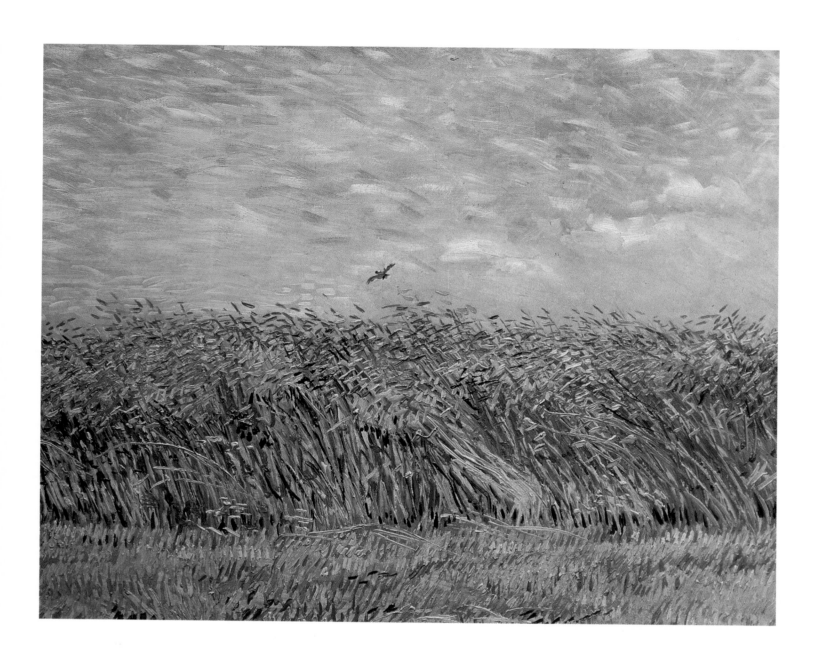

Wheatfield with Lark June 1888
Oil on canvas, 21¼ x 25⅝ in.
Rijksmuseum Vincent van Gogh
Amsterdam/Bridgeman Art Library

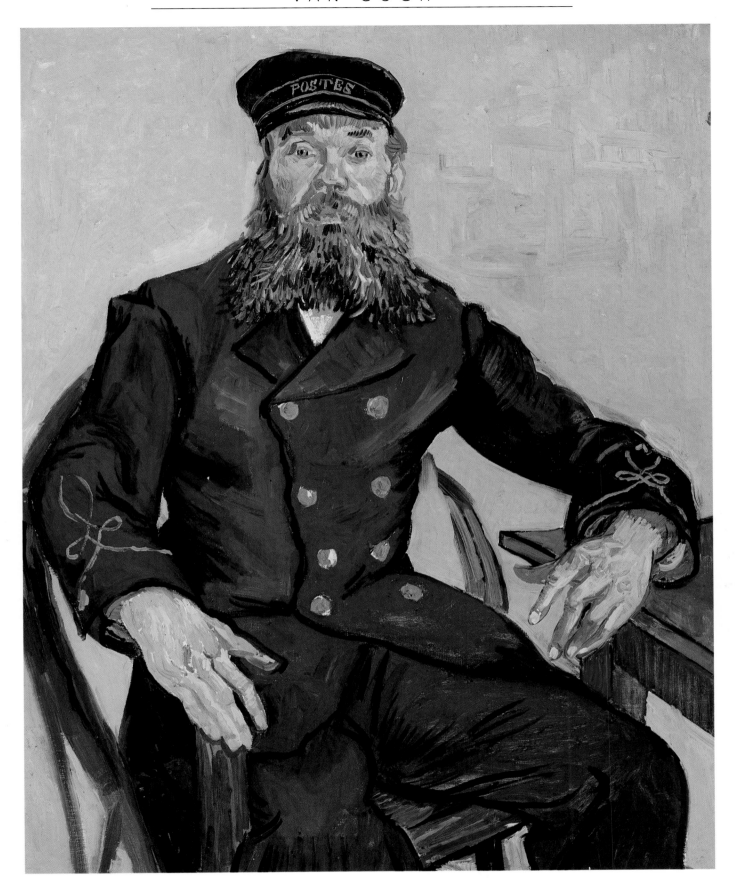

Postman Joseph Roulin July 1888
Oil on canvas, 32 x25¾ in.
Museum of Fine Arts,
Boston, MA

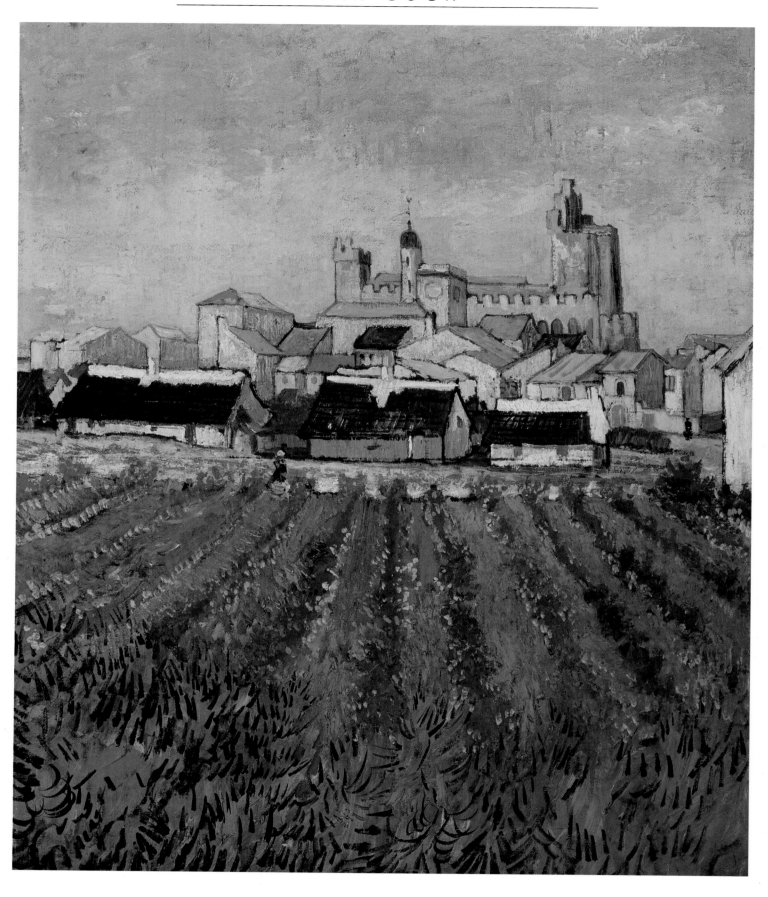

View of Saintes-Maries June 1888
Oil on canvas, 25⅛ x 20⁹⁄₁₀ in.
Collection State Museum Kröller-Müller,
Otterlo, The Netherlands

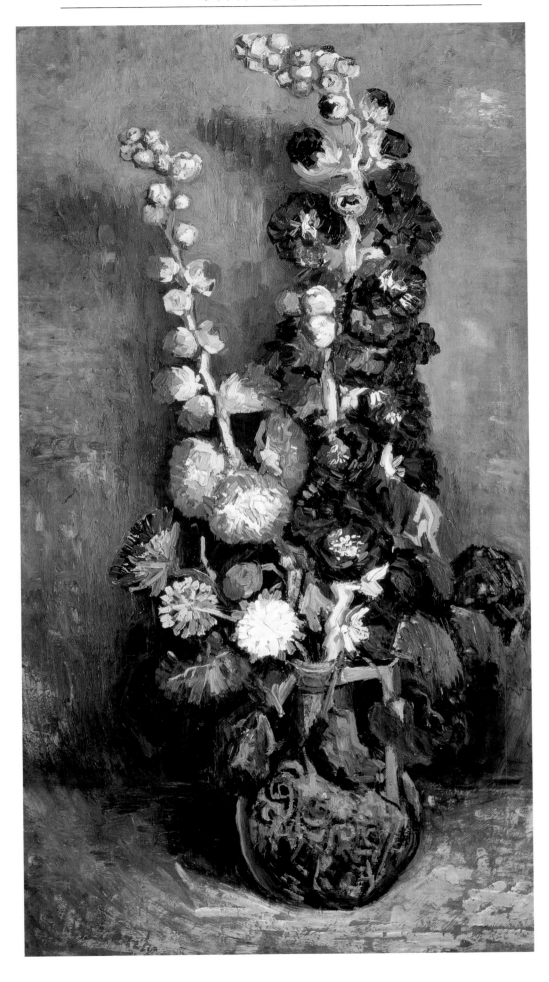

Vase of Hollyhocks 1886
Oil on canvas, 35⅝ x 19⁹⁄₁₀ in.
Kunsthaus, Zürich/Bridgeman Art Library, London

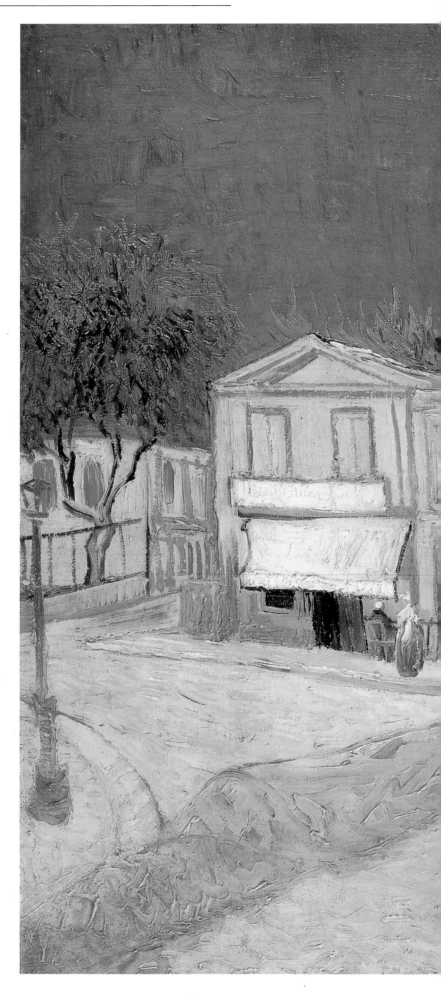

The Yellow House in Arles September 1888
Oil on canvas, 30 x 37 in.
Rijksmuseum Vincent van Gogh,
Amsterdam

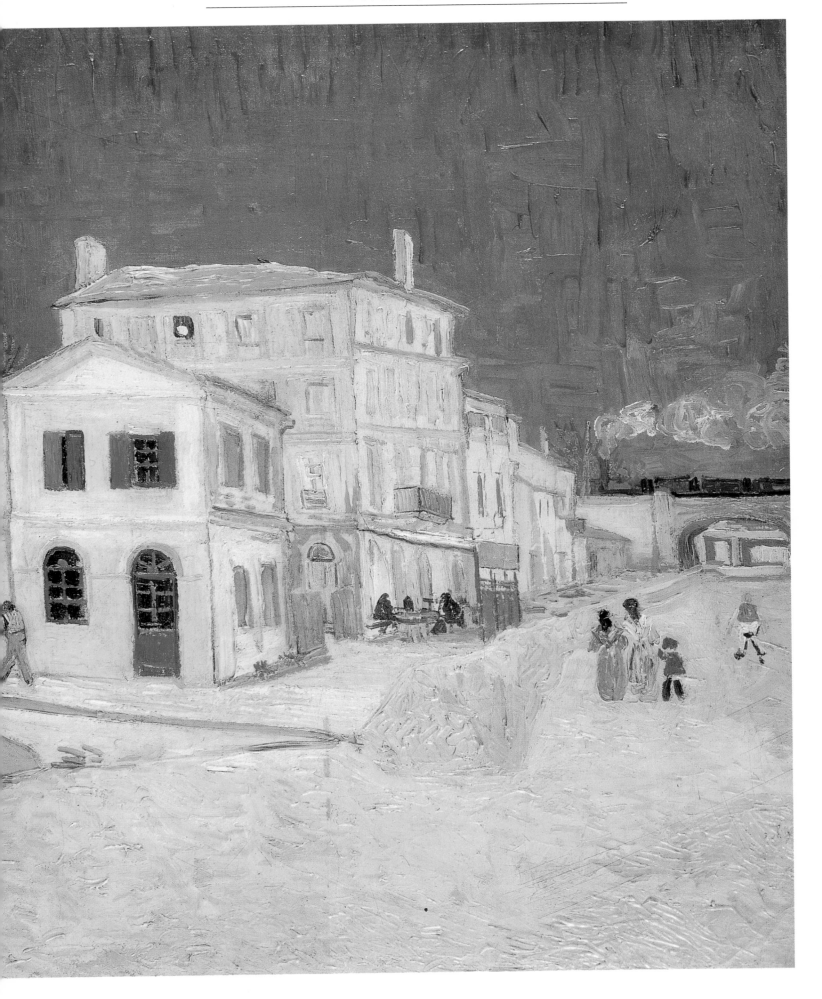

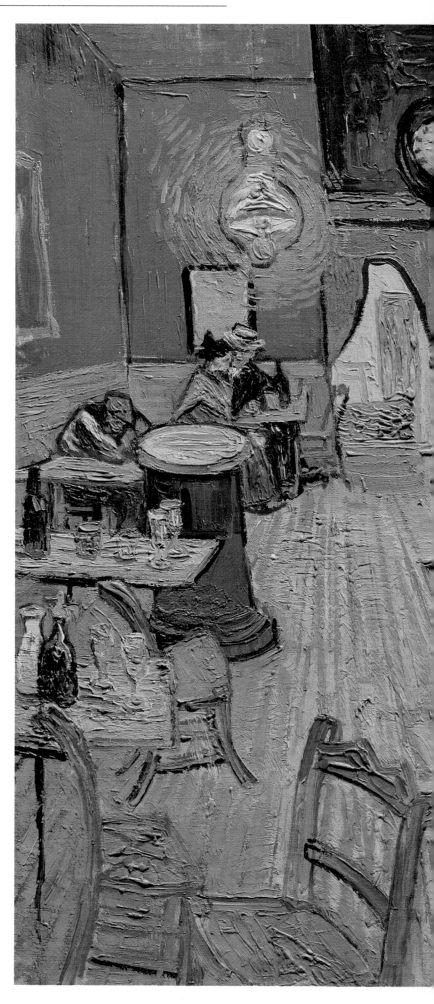

The Night Café 1888
Oil on canvas, 28½ x 36¼ in.
Yale University Art Gallery, New Haven, Connecticut
Bequest of Stephen Carlton Clark, B. A. 1903

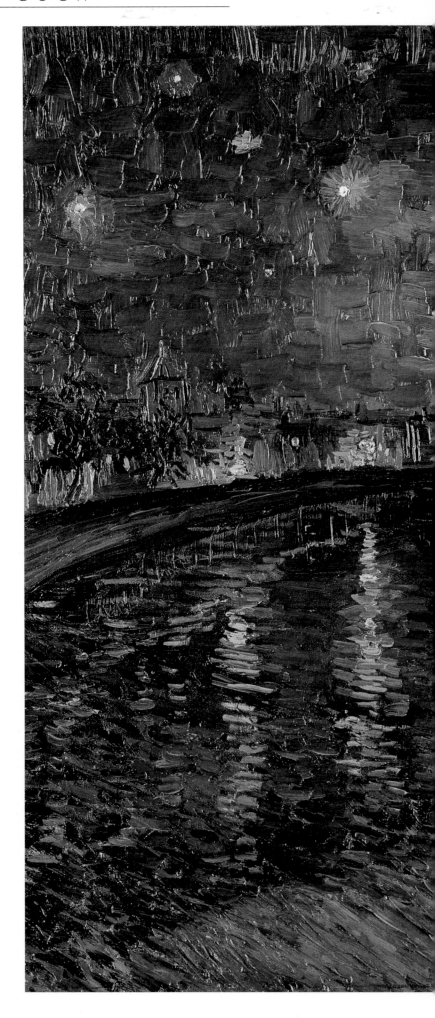

The Starry Night, Arles
Oil on canvas, 29 x 36¼ in.
Musée d'Orsay,
Paris

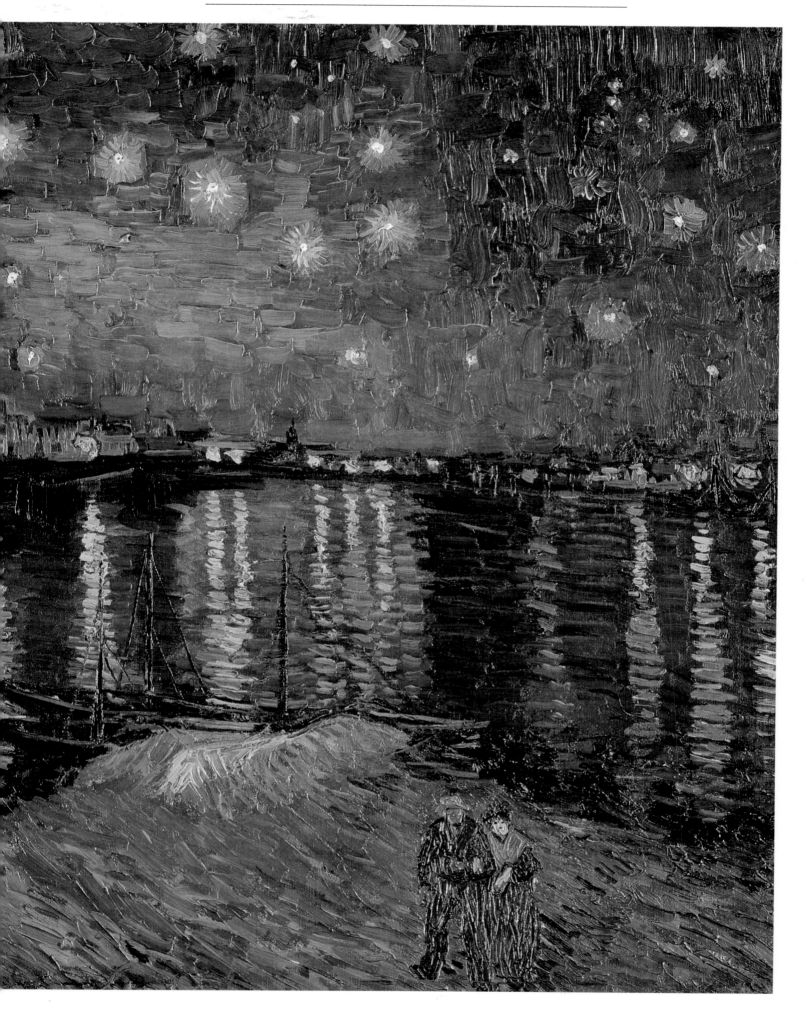

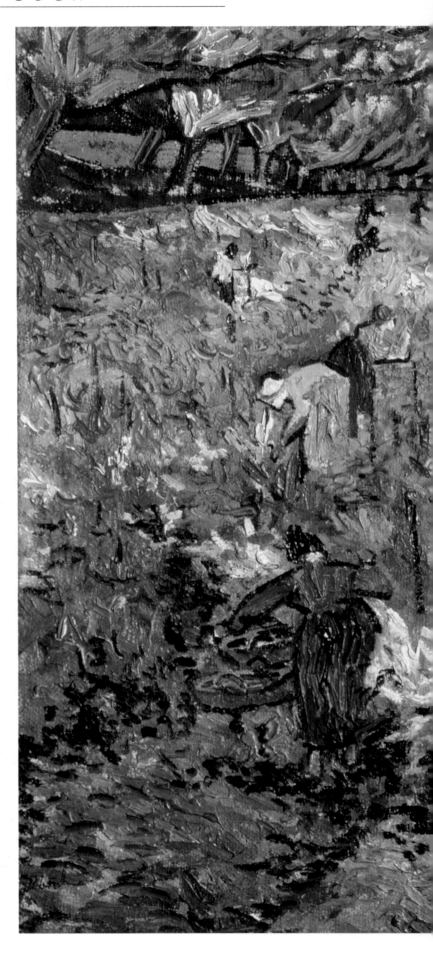

Red Vineyards at Arles, 1888
Oil on canvas, 29½ x 36½ in.
Pushkin Museum, Moscow/Bridgeman Art Library, London

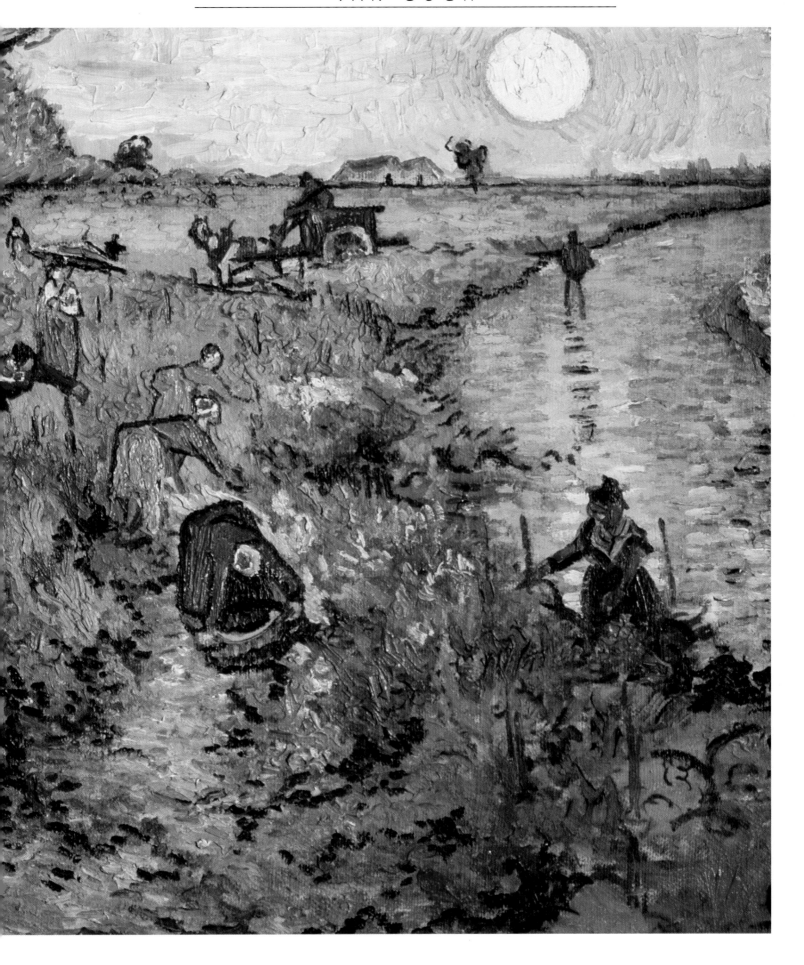

Les Alyscamps November 1888
Oil on canvas, 28¾ x 36¼ in.
Collection State Museum Kröller-Müller,
Otterlo, The Netherlands

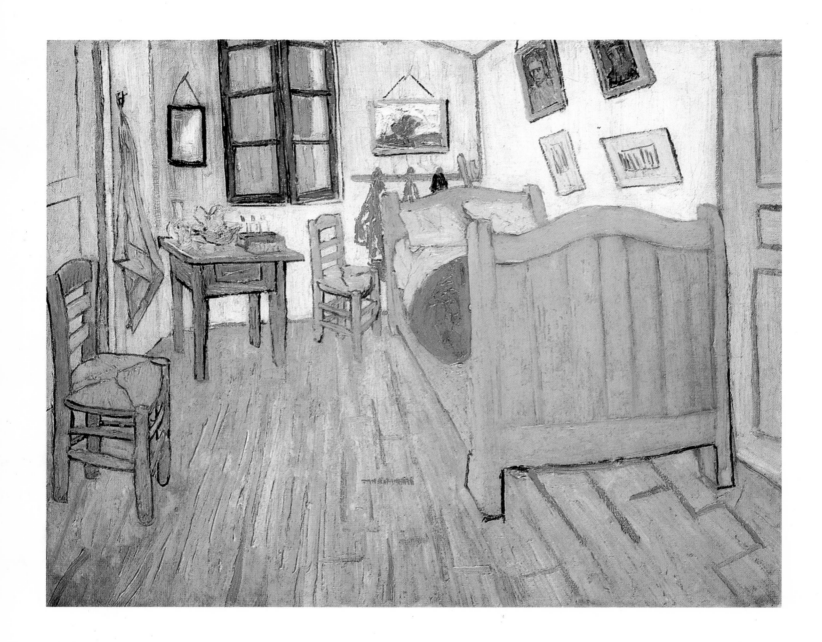

Van Gogh's Bedroom October 1888
Oil on canvas, 28¼ x 35½ in.
Rijkmuseum Vincent van Gogh,
Amsterdam

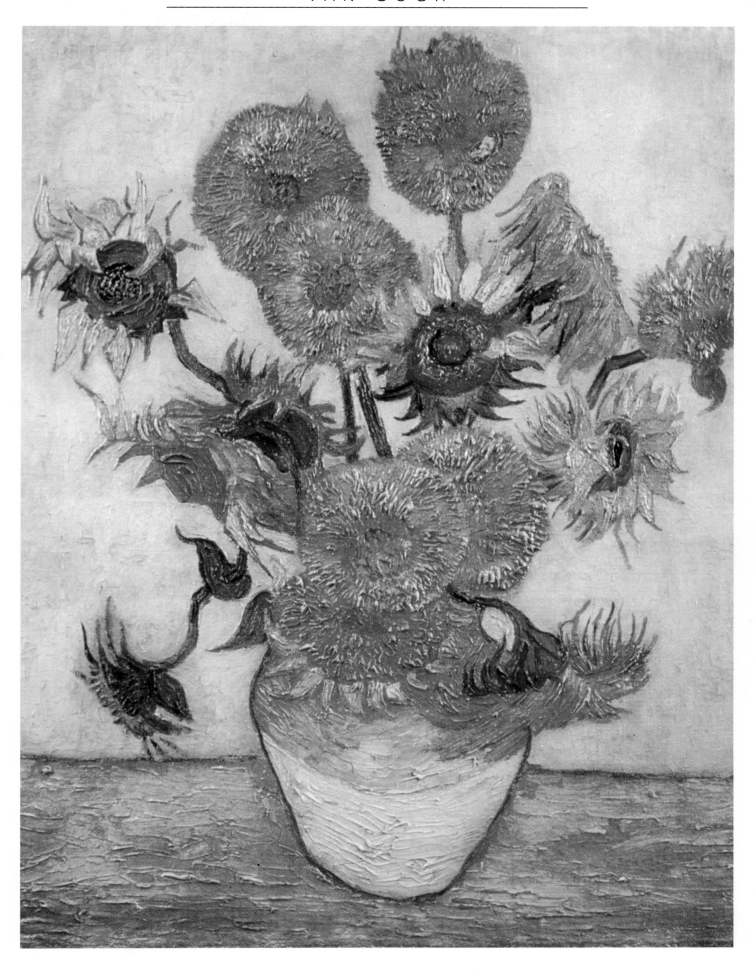

Sunflowers 1889
Oil on canvas, 39½ x 30 in.
Christie's Images, London

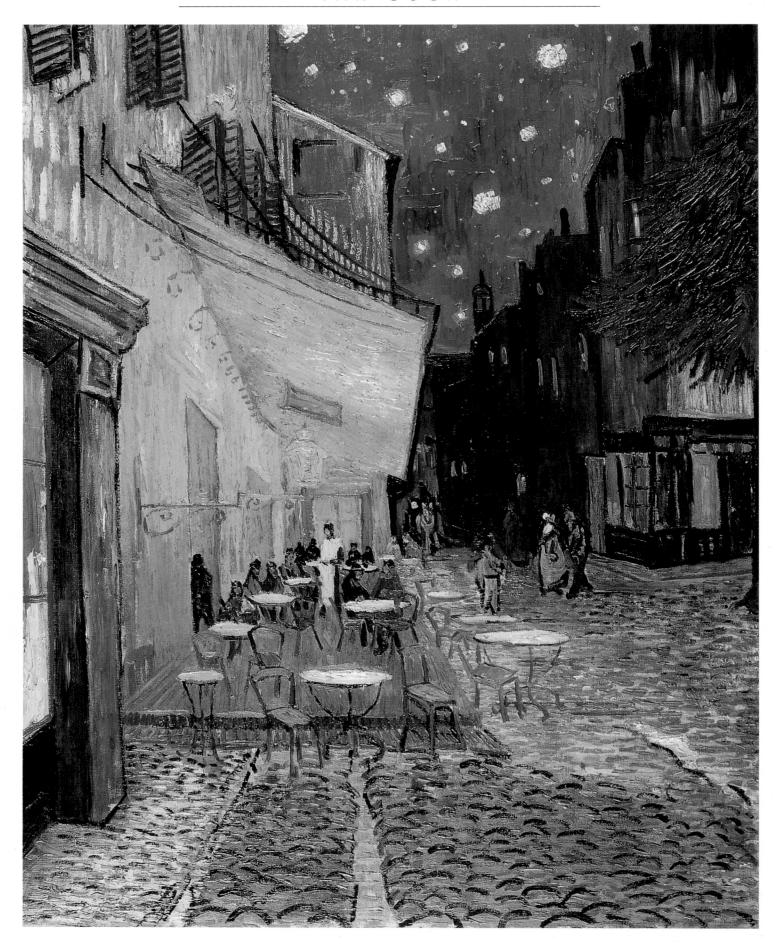

The Café Terrace, Arles at Night September 1888
Oil on canvas, 32 x 25¾ in.
Collection State Museum Kröller-Müller,
Otterlo, The Netherlands

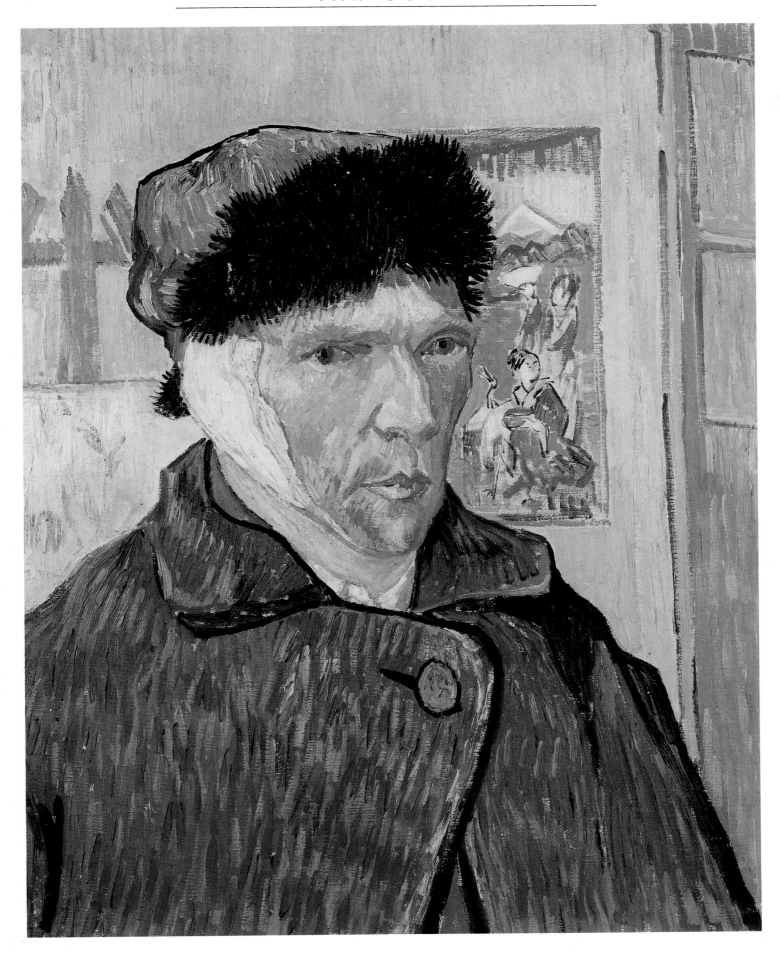

Self-Portrait with Bandaged Ear January 1889
Oil on canvas, 23½ x 19¼ in.
Courtauld Institute Galleries,
London

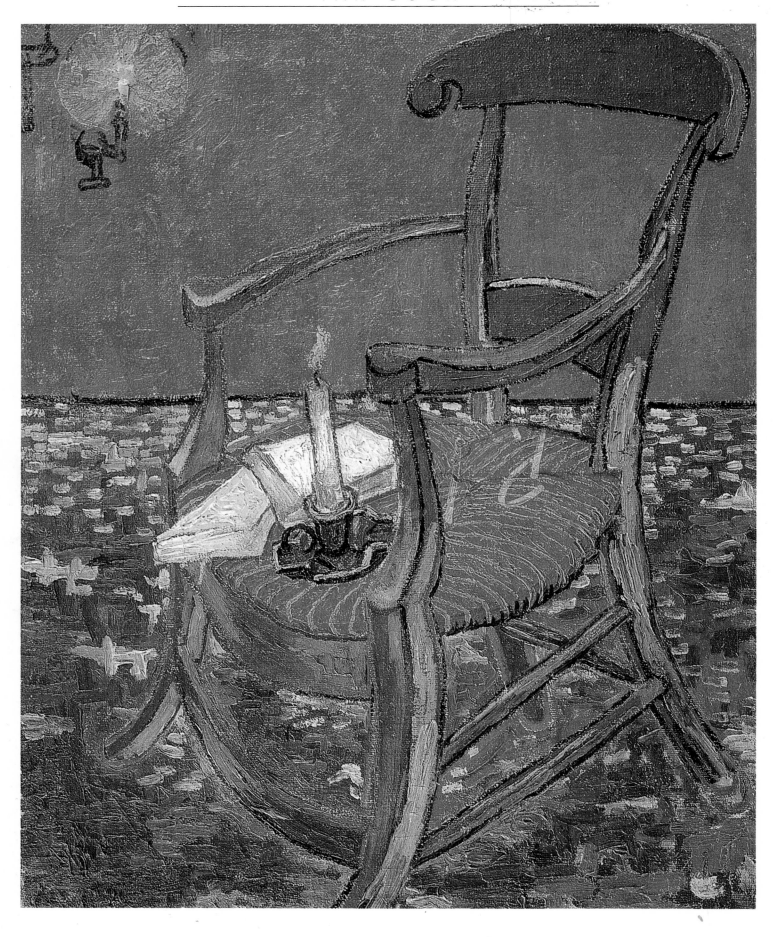

Gauguin's Chair December 1888
Oil on canvas, 36½ x 28¼ in.
Rijksmuseum Vincent van Gogh,
Amsterdam

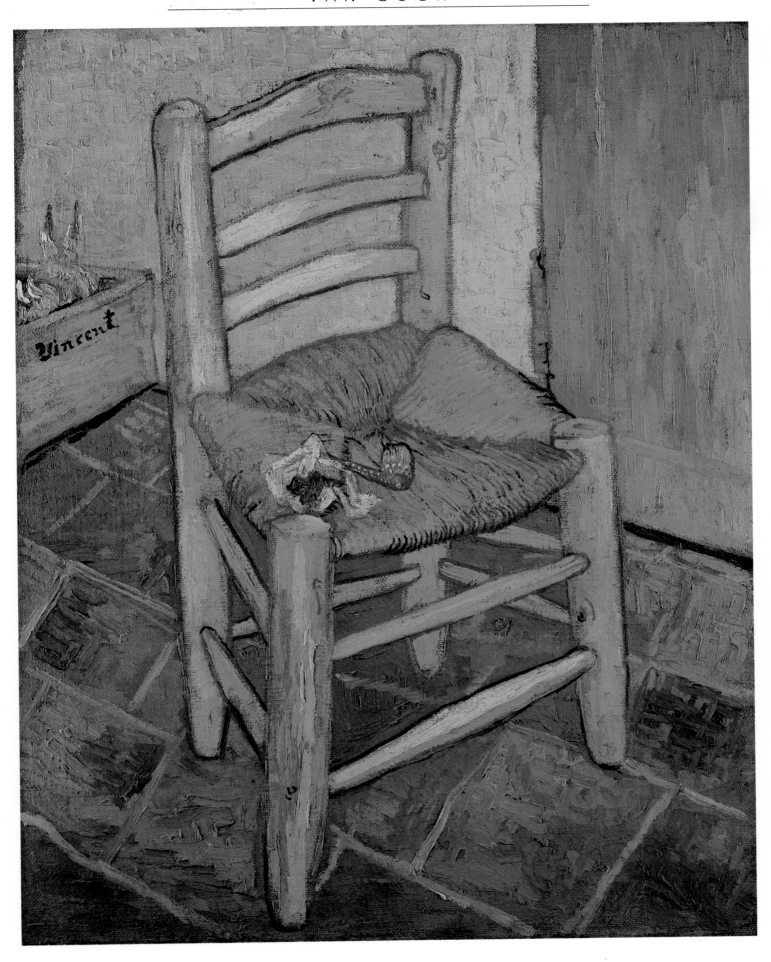

Van Gogh's Chair December 1888
Oil on canvas, 36½ x 29 in.
Courtesy of the Trustees of the National Gallery,
London

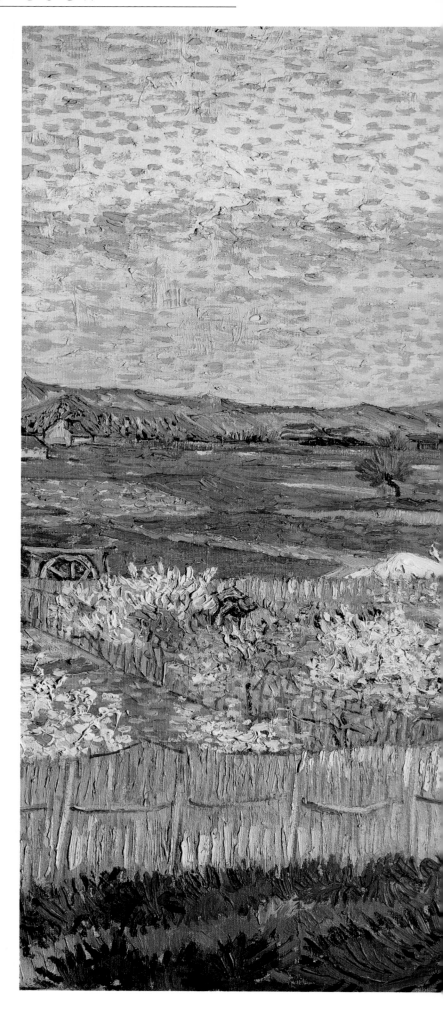

The Crau with Peach Trees in Blossom April 1889
Oil on canvas, 25¾ x 32 in.
Courtauld Institute Galleries,
London

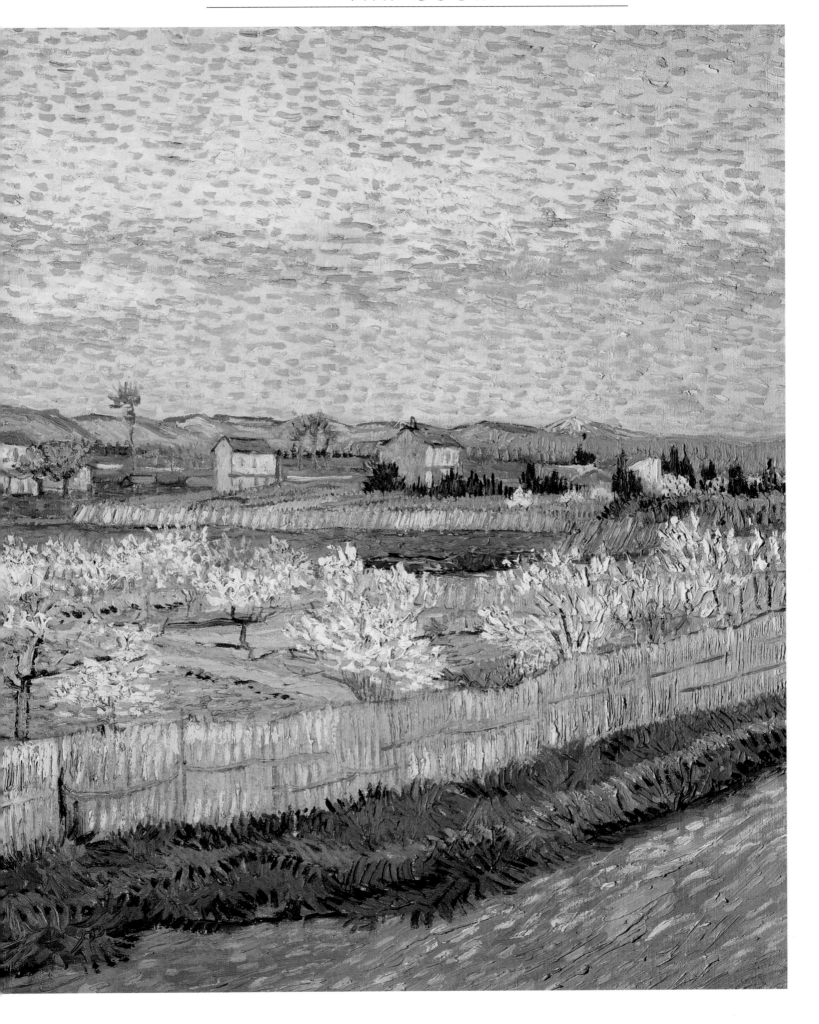

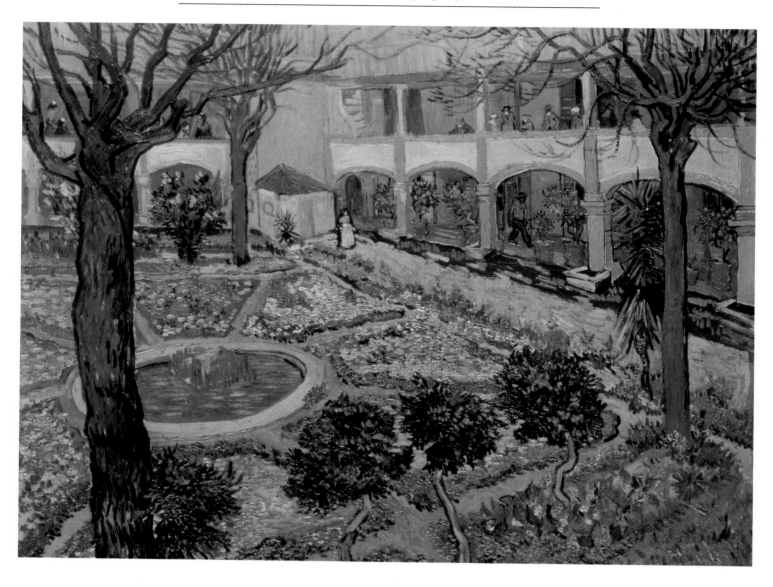

The Asylum Garden at Arles 1889
Oil on canvas, 28¾ x 36¼ in.
Oskar Reinhart Collection
Winterhur, Switzerland/Bridgeman Art Library, London

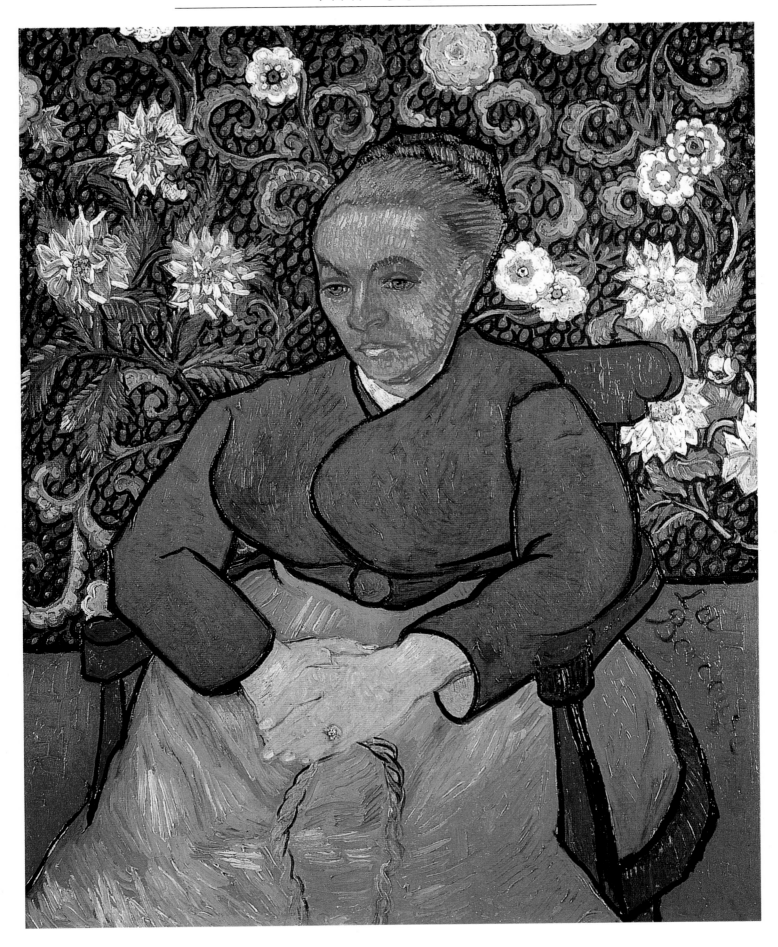

La Berceuse: Madame Augustine Roulin January 1889
Oil on canvas, 36¼ x 28¾ in.
Collection State Museum Kröller-Müller,
Otterlo, The Netherlands

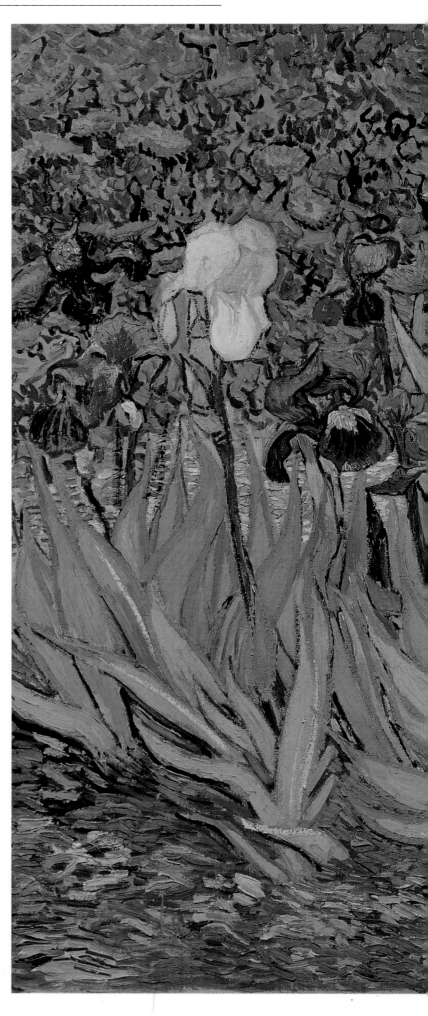

Irises May 1889
Oil on canvas, 28 x 37 in.
J Paul Getty Museum,
Malibu, CA

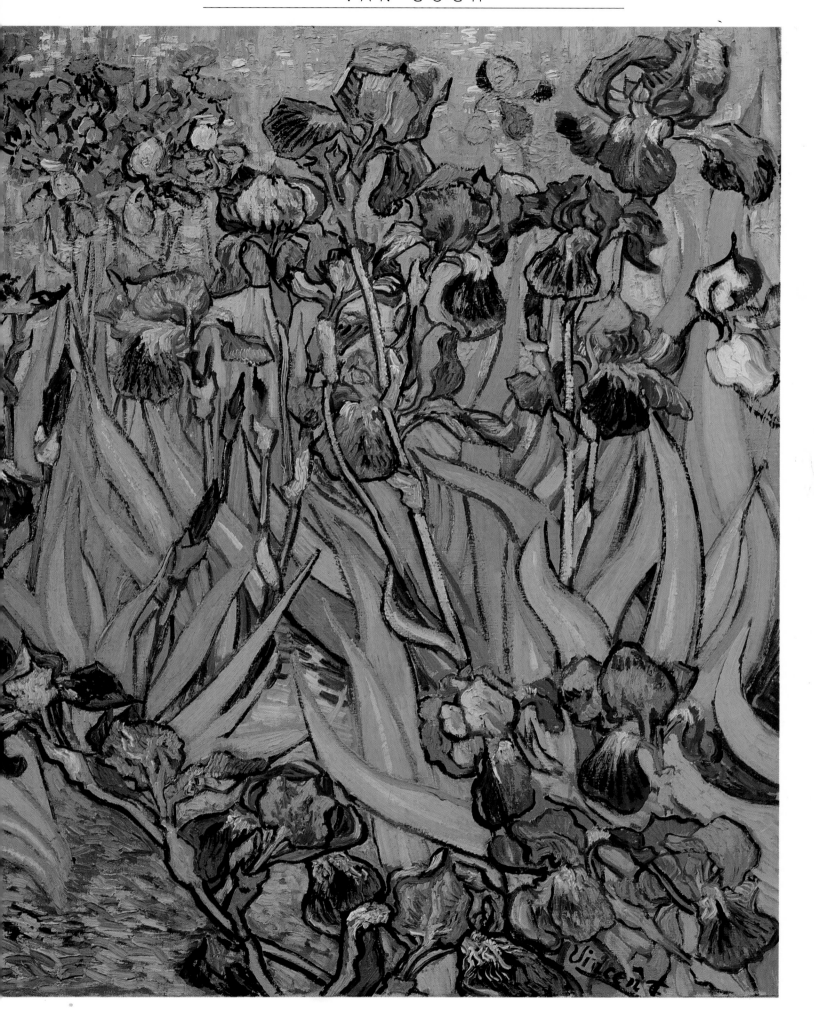

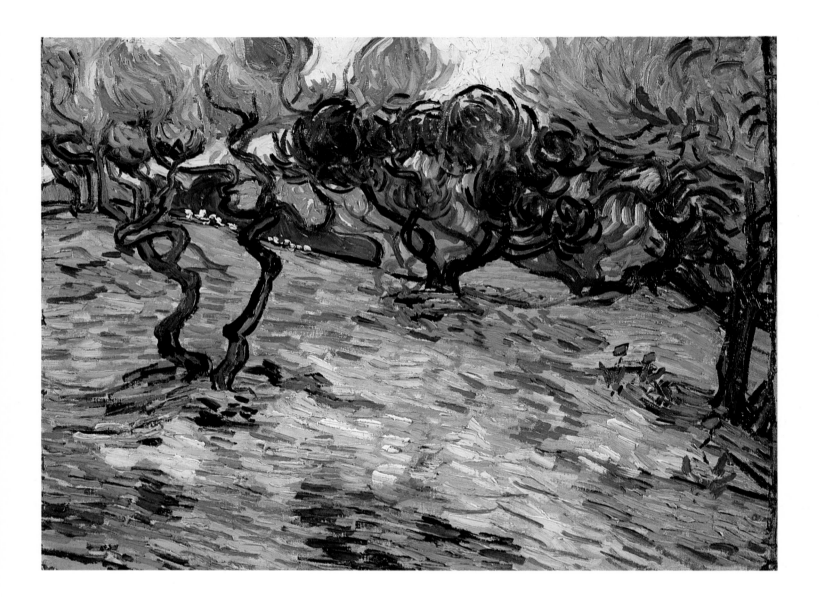

Olive Trees September-November 1889
Oil on canvas, 19⅜ x 24¾ in.
National Gallery of Scotland, Edinburgh

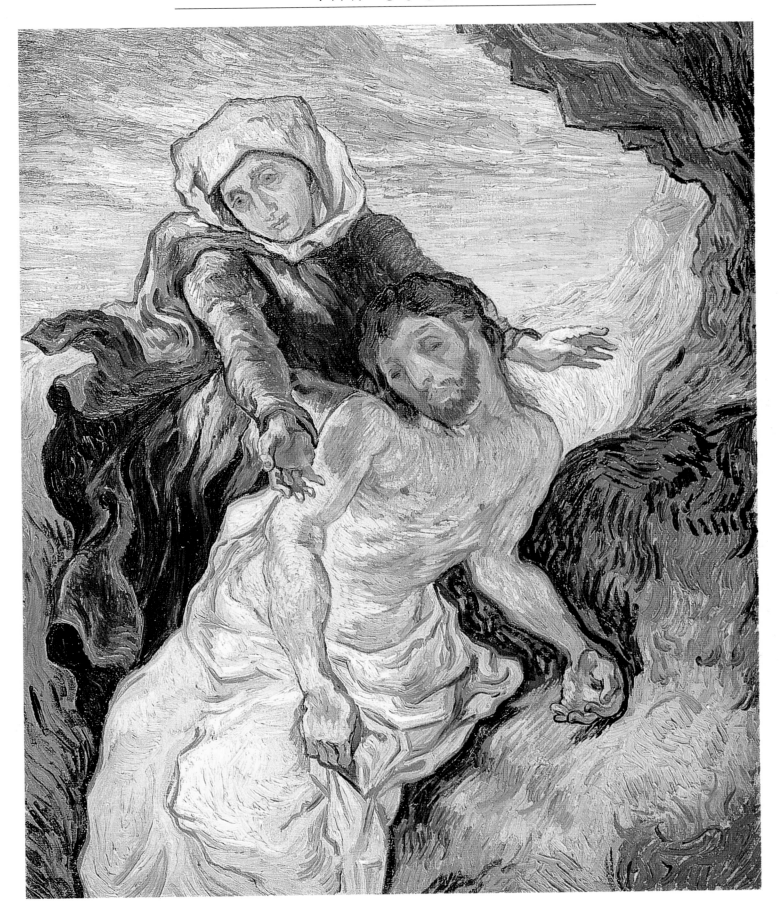

Pietà (after Delacroix) September 1889
Oil on canvas, 28¾ x 23¾ in.
Rijkmuseum Vincent van Gogh,
Amsterdam

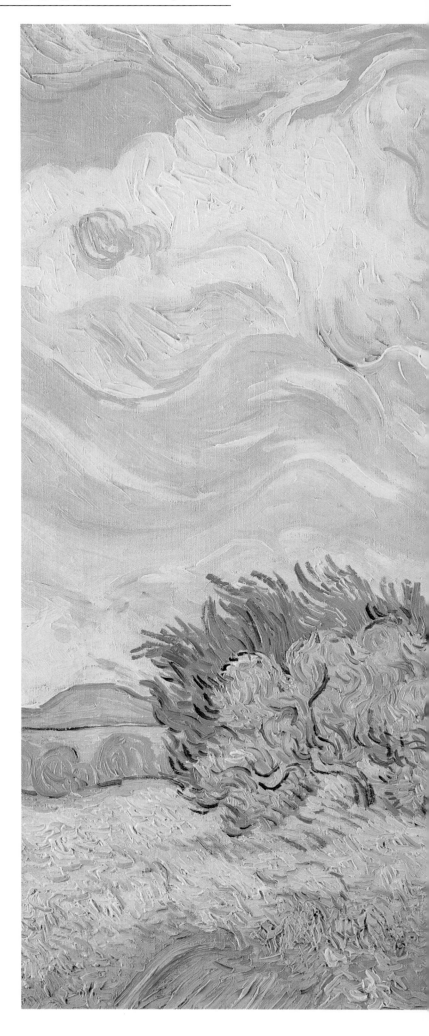

A Cornfield with Cypresses July 1889
Oil on canvas, 28½ x 36¼ in.
Courtesy of the Trustees of the National Gallery,
London

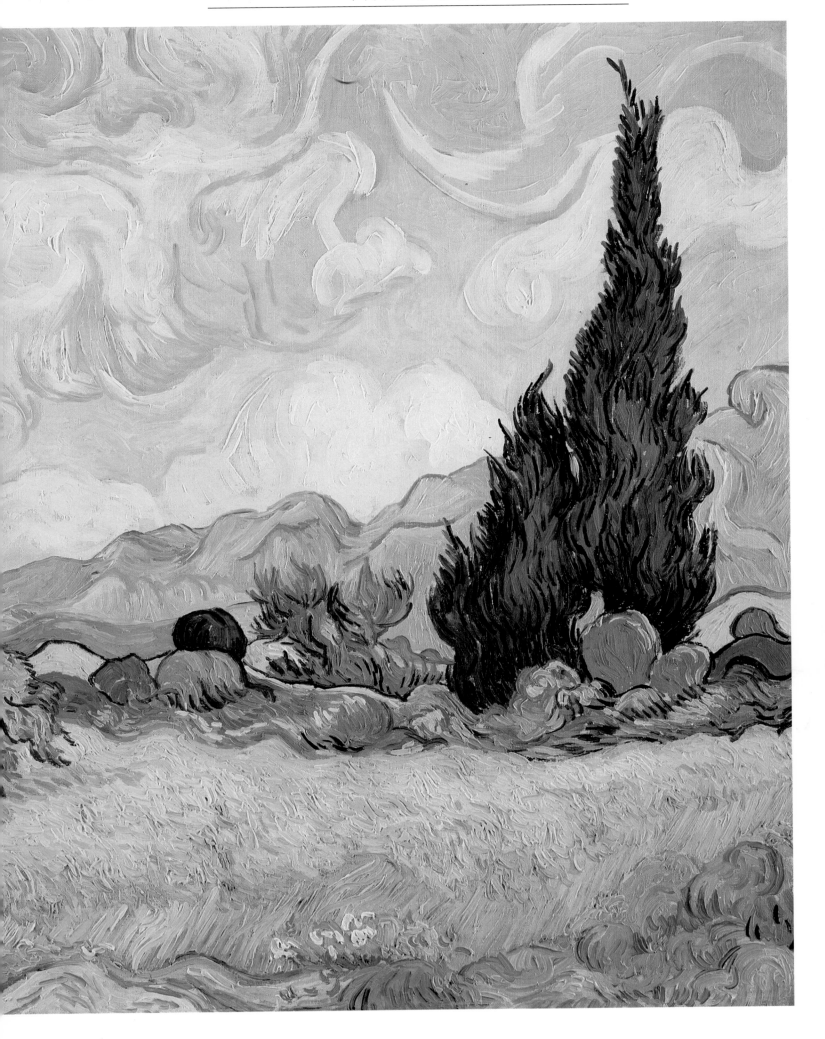

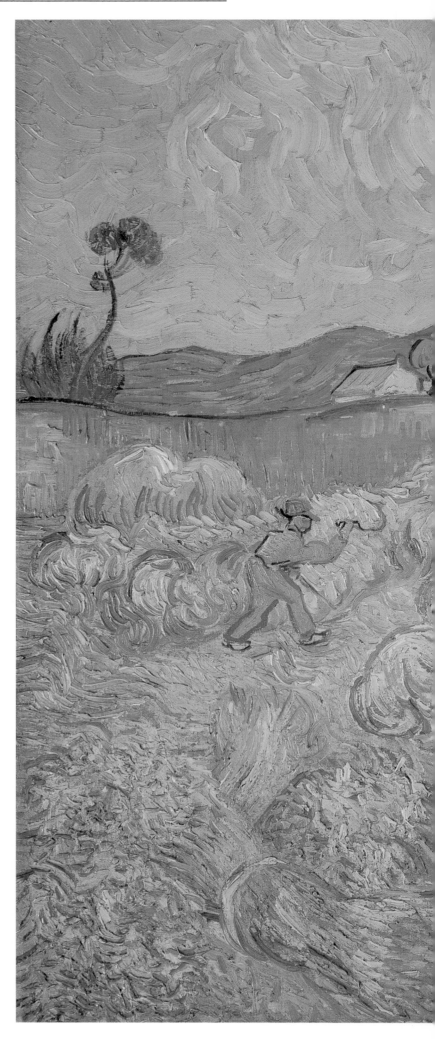

Weatfield with a Reaper July 1889
Oil on canvas, 28¾ x 36¼ in.
Rijksmuseum Vincent van Gogh,
Amsterdam

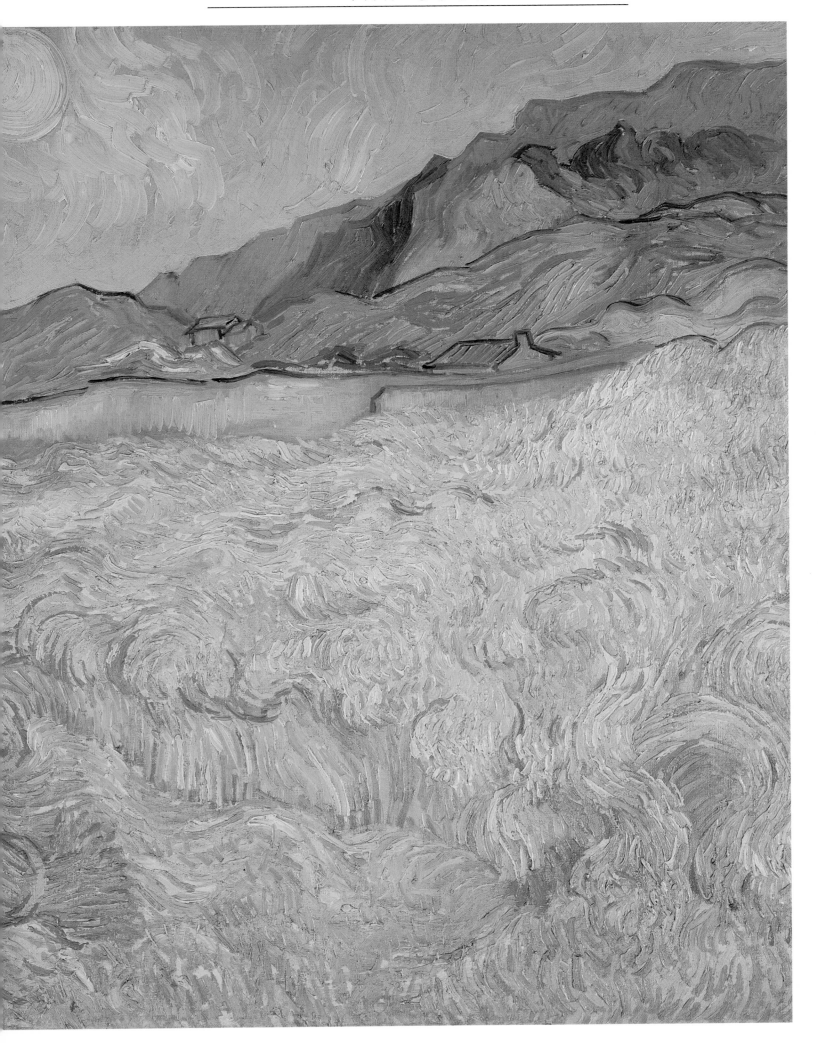

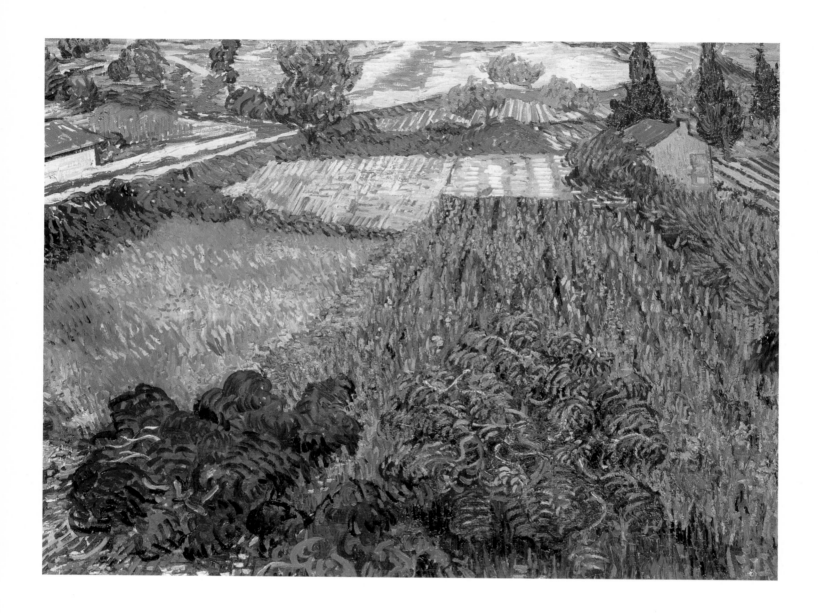

Field with Poppies 1889
Oil on canvas, 28 x 21¼ in.
Kunsthalle, Bremen/Bridgeman Art Library, London

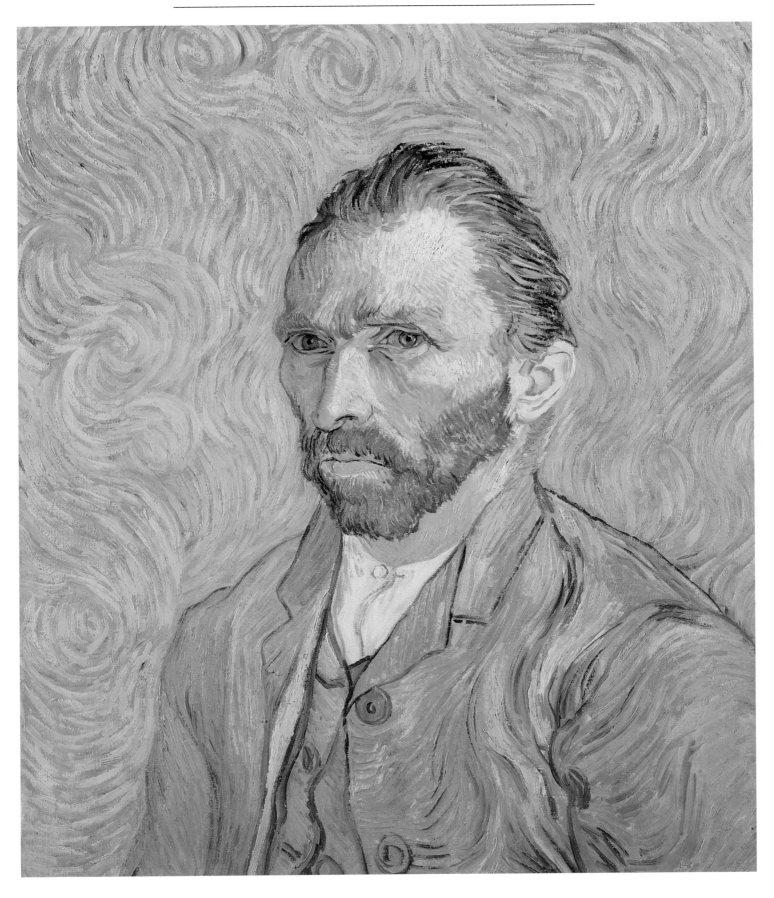

Self-Portrait September 1889
Oil on canvas, 25½ x 21¼ in.
Musée d'Orsay,
Paris

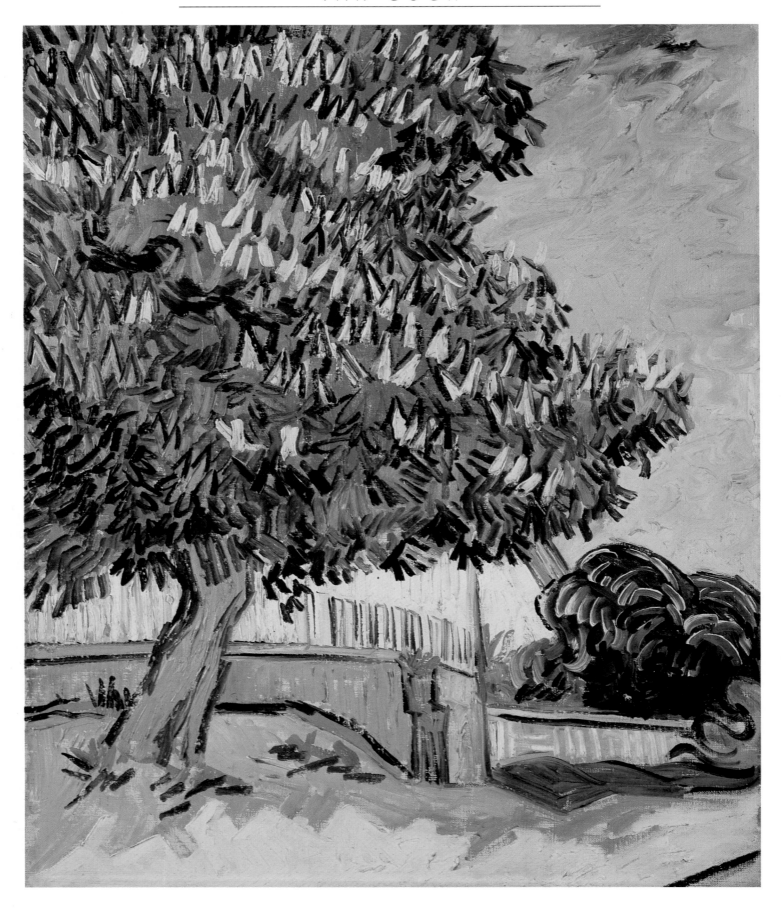

Chestnut Tree in Blossom
Oil on canvas, 24⅝ x 19⁷⁄₁₀ in.
Collection State Museum Kröller-Müller,
Otterlo, The Netherlands

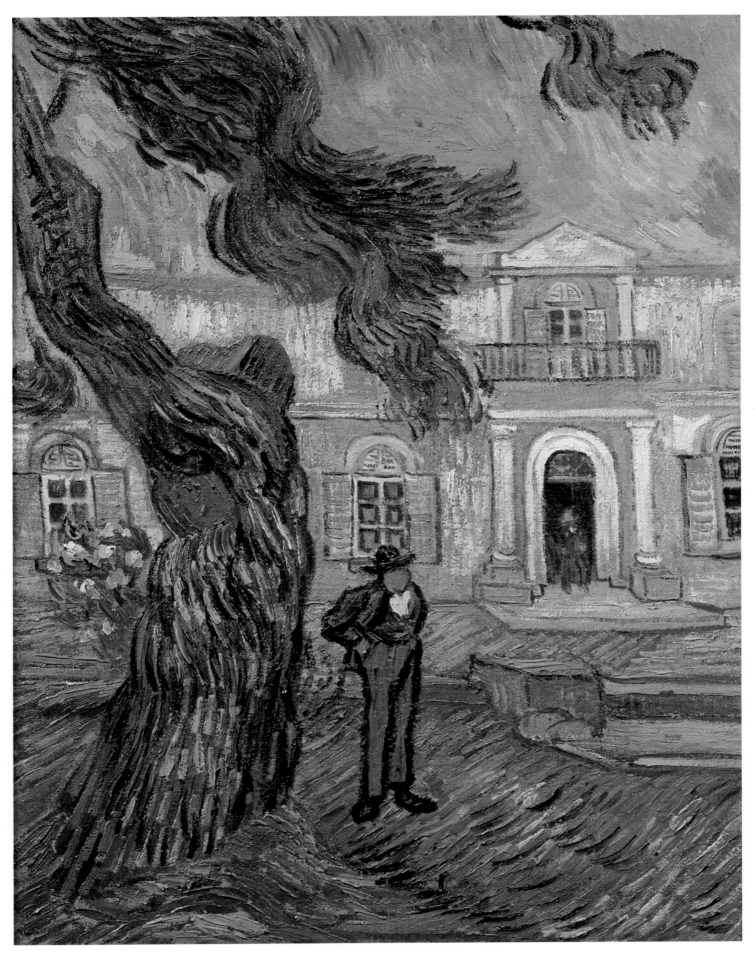

St Paul's Hospital, St Rémy 1889
Oil on canvas,
Musée d'Orsay,
Paris

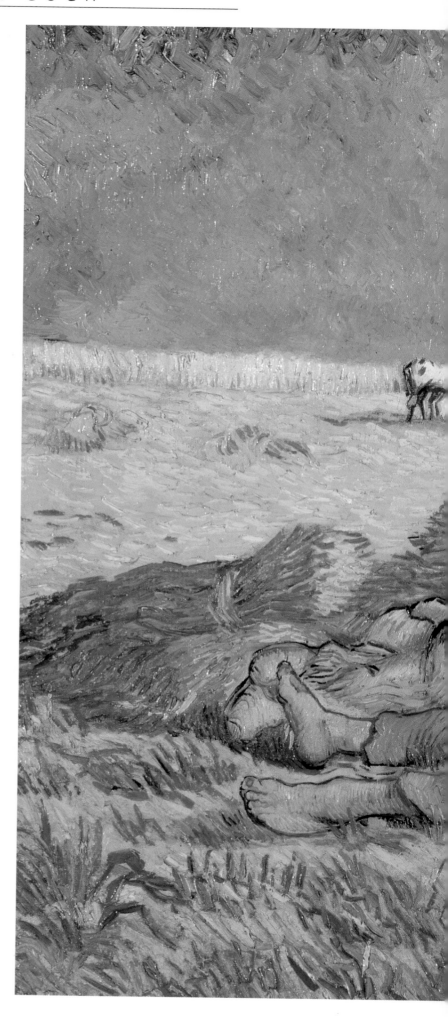

La Méridienne (after Millet) Spring 1890
Oil on canvas, 28½ x 25½ in.
Musée d'Orsay,
Paris

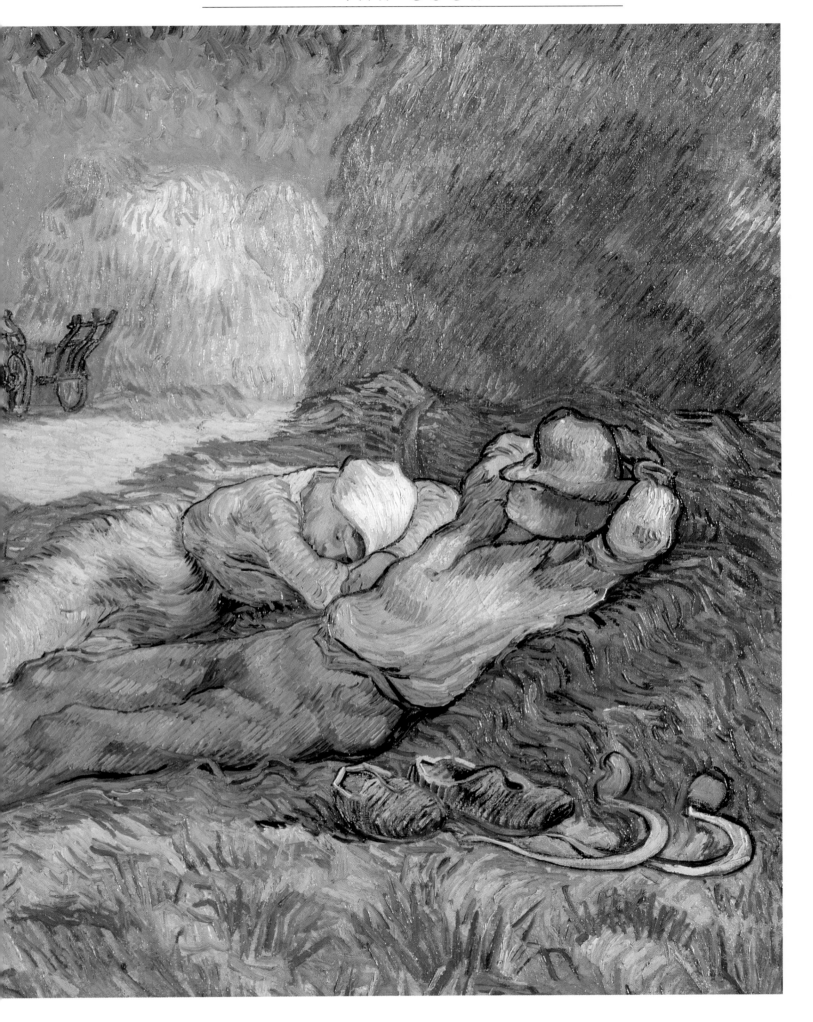

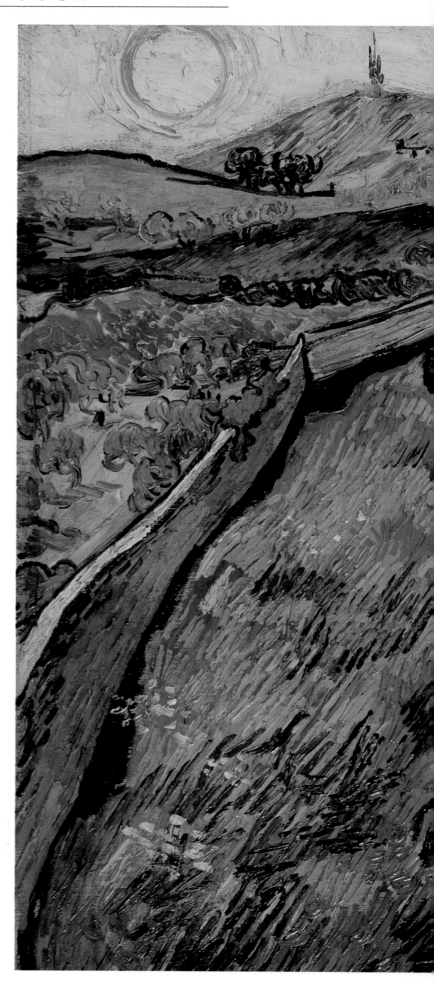

The Enclosed Field at Sunrise Spring 1890
Oil on canvas, 28⅓ x 36¼ in.
Collection State Museum Kröller-Müller,
Otterlo, The Netherlands

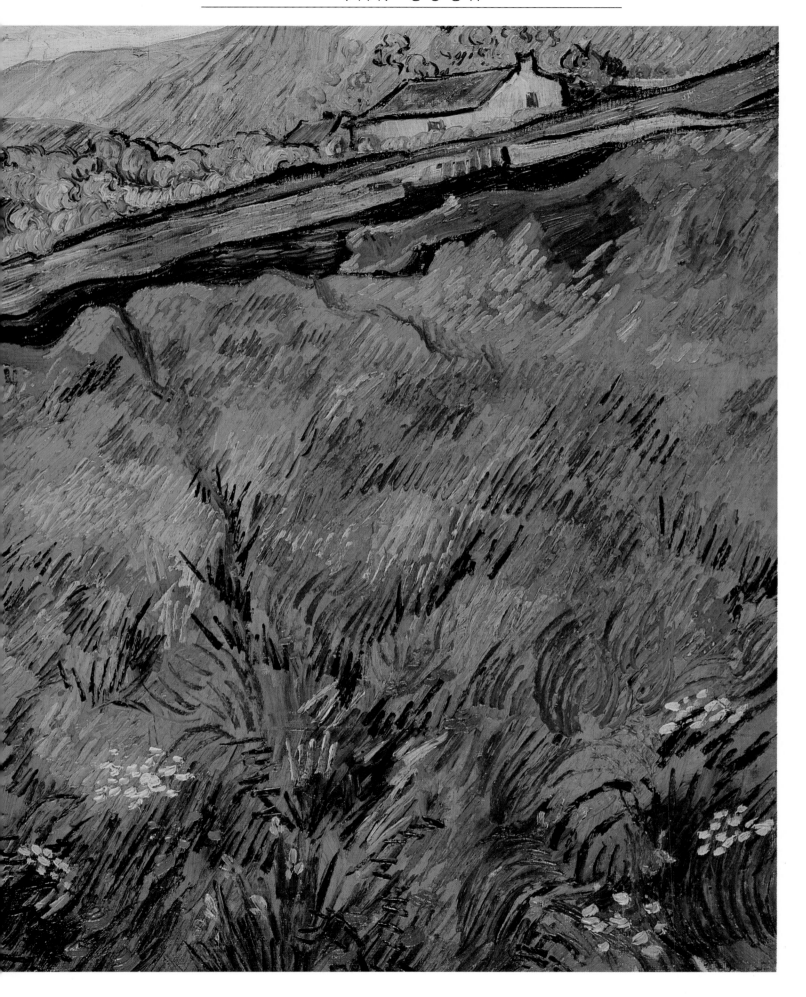

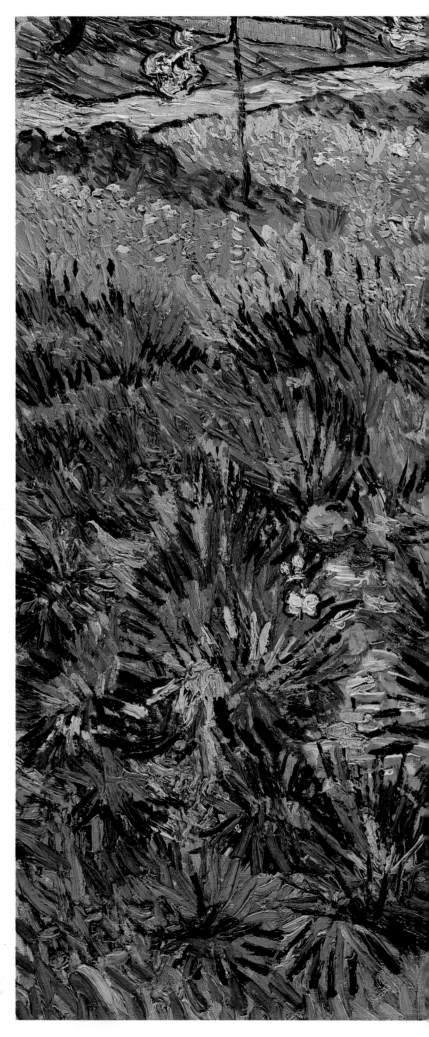

Long Grass with Butterflies c.1890
Oil on canvas, 25⅜ x 31¾ in.
Courtesy the Trustees of the National Gallery,
London

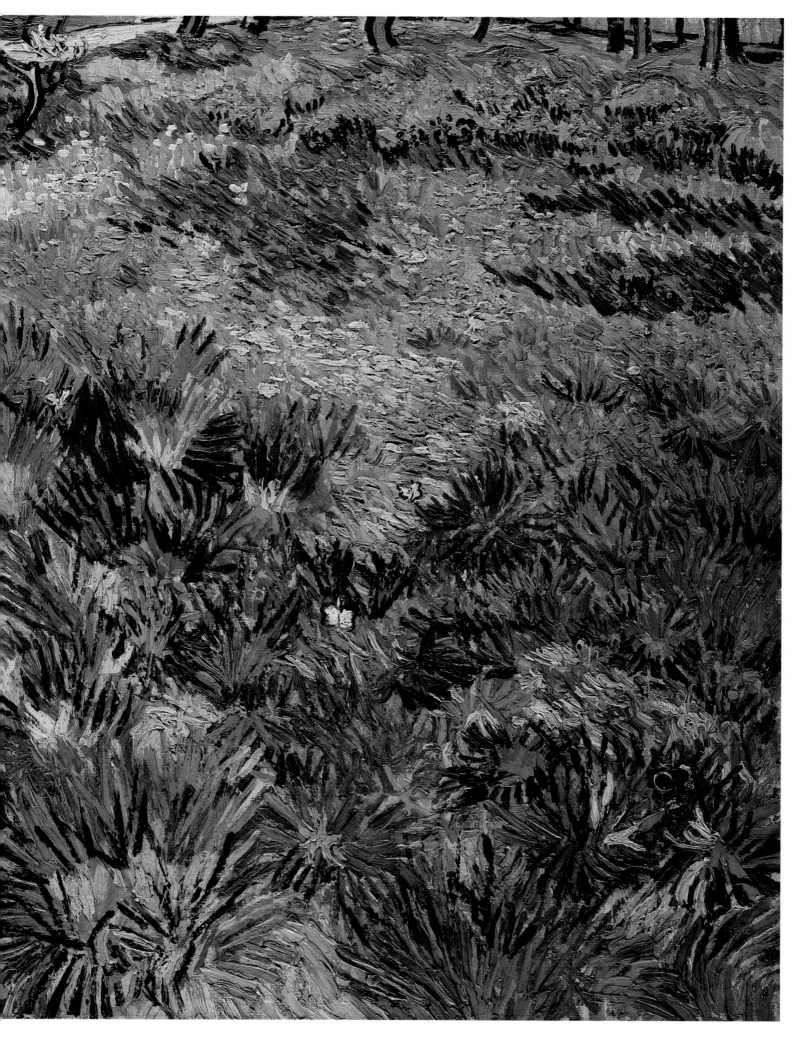

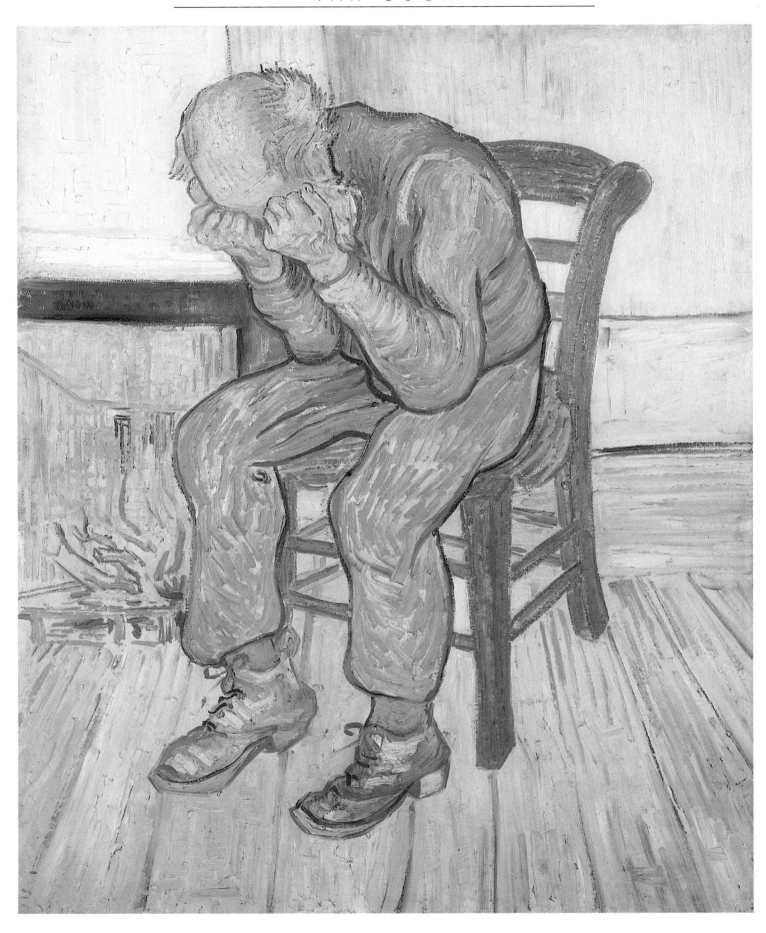

Worn Out May 1890
Oil on canvas, 32 x 25½ in.
Collection State Museum Kröller-Müller,
Otterlo, The Netherlands

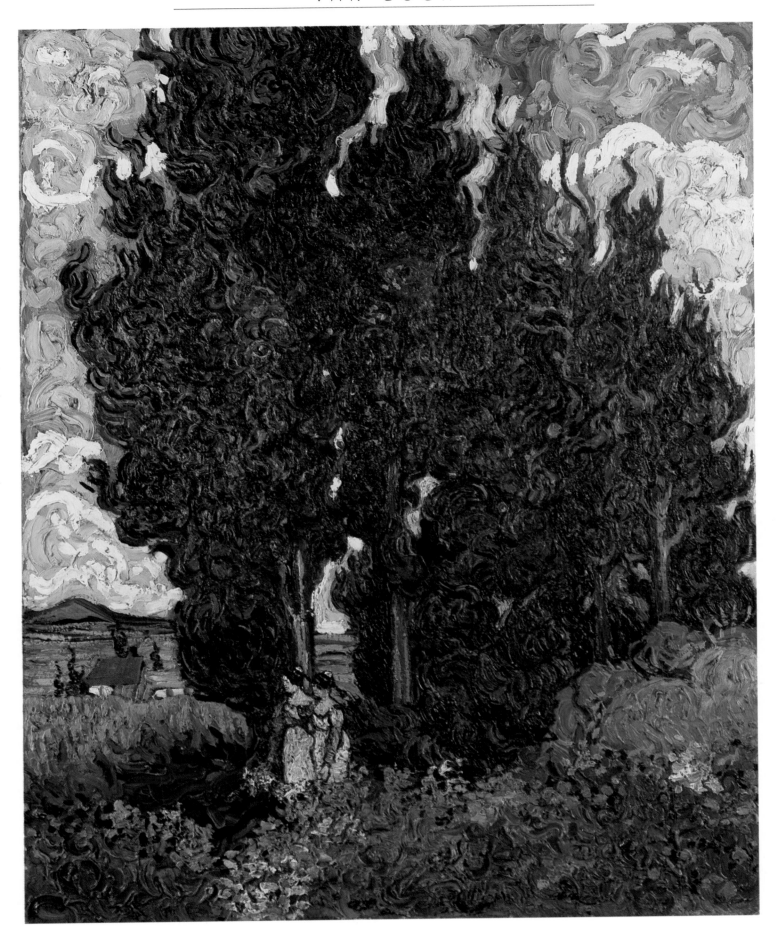

Cypresses with Two Figures June 1889-February 1890
Oil on canvas, 36¼ x 28¾ in.
Collection State Museum Kröller-Müller,
Otterlo, The Netherlands

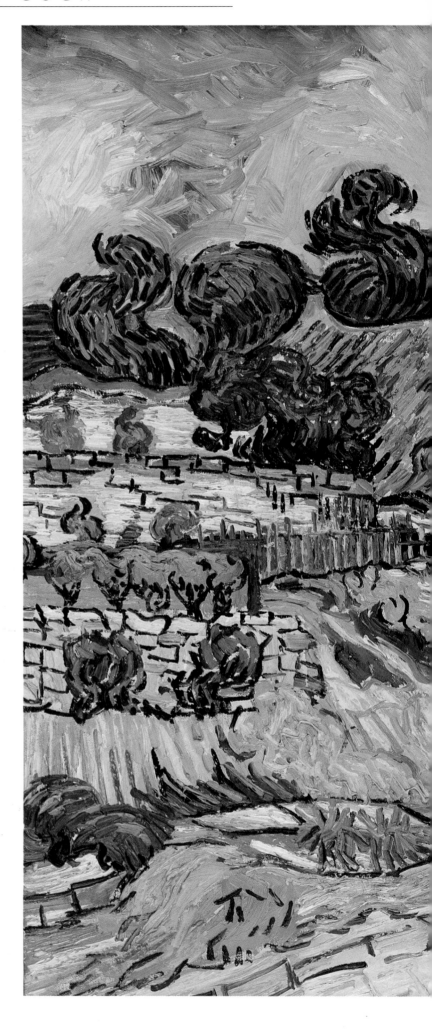

Thatched Cottages at Cordeville June 1890
Oil on canvas, 28¼ x 25¾ in.
Musée d'Orsay,
Paris

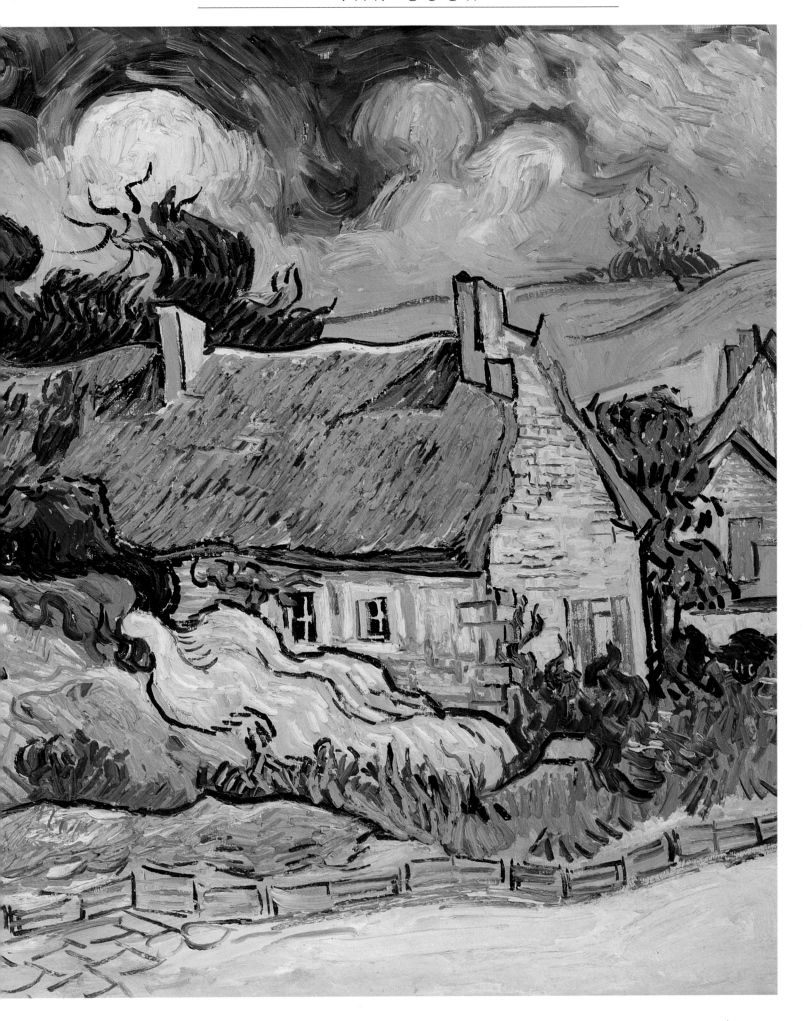

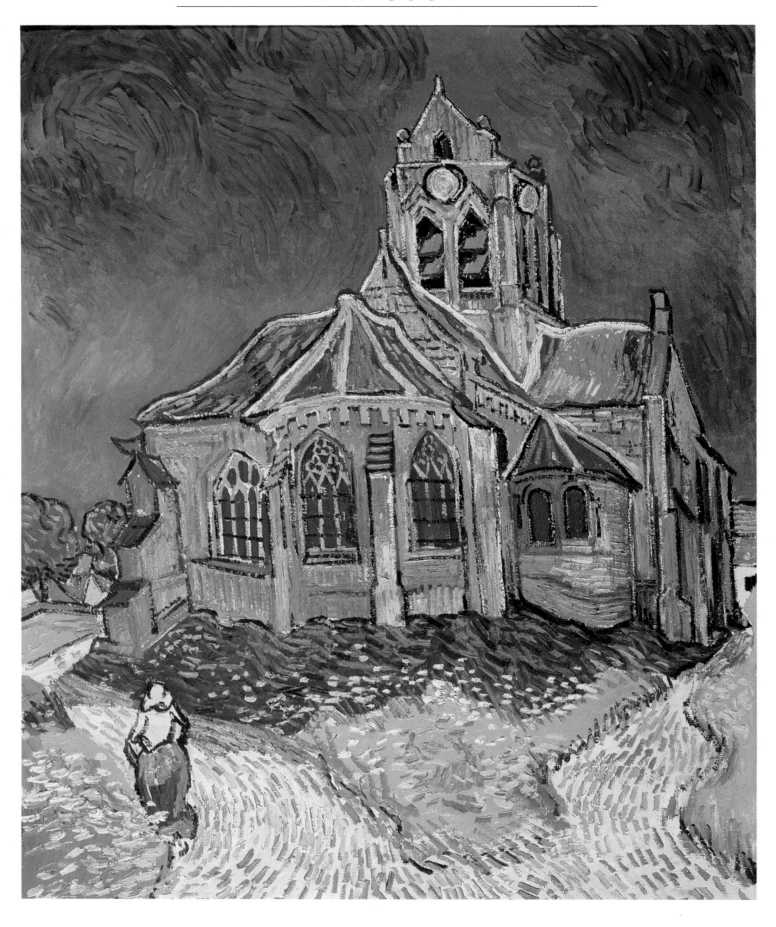

The Church at Auvers June 1890
Oil on canvas, 37 x 29¾ in.
Musée d'Orsay,
Paris

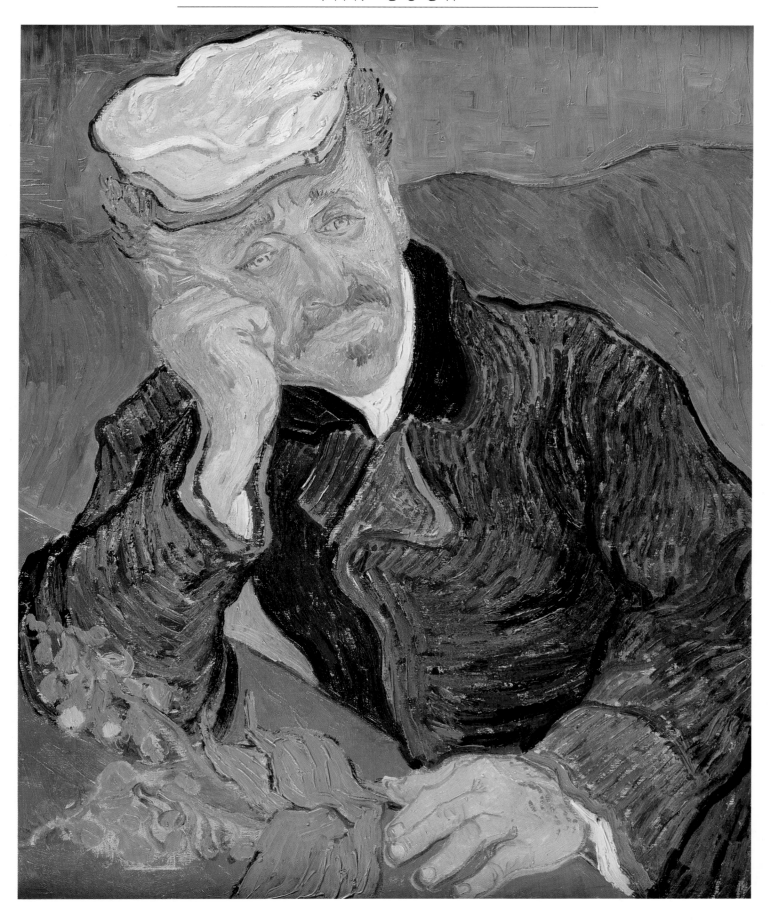

Dr Paul Gachet, June 1890
Oil on canvas, 26¾ x 22½ in.
Musée d'Orsay,
Paris

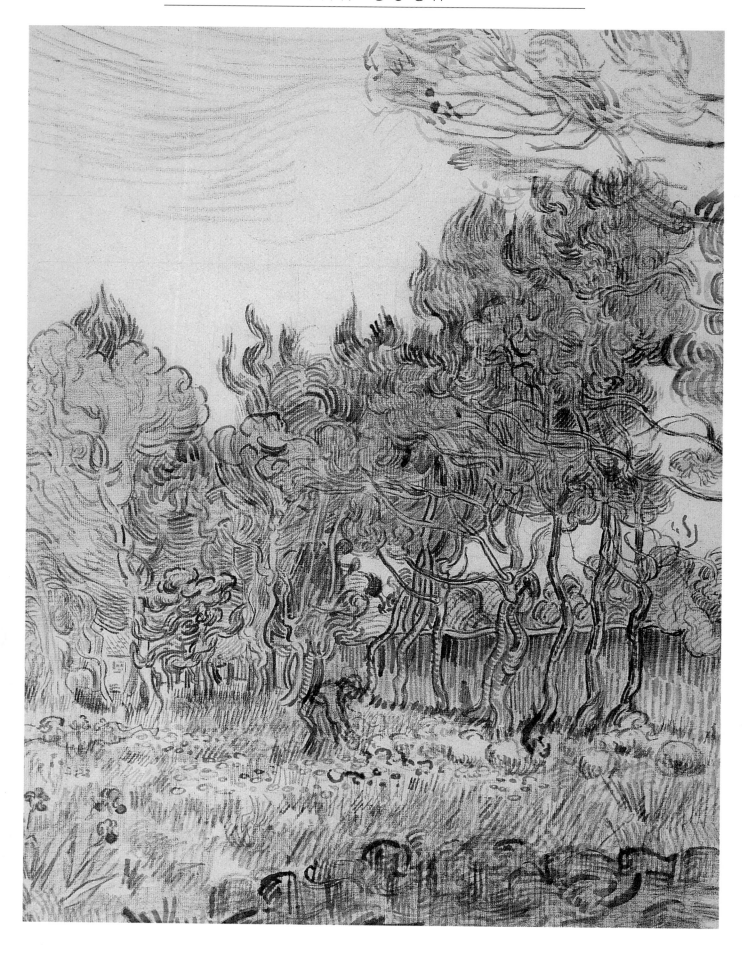

Garden at St Rémy
Oil on canvas, 18 x 12 in.
The Tate Gallery,
London

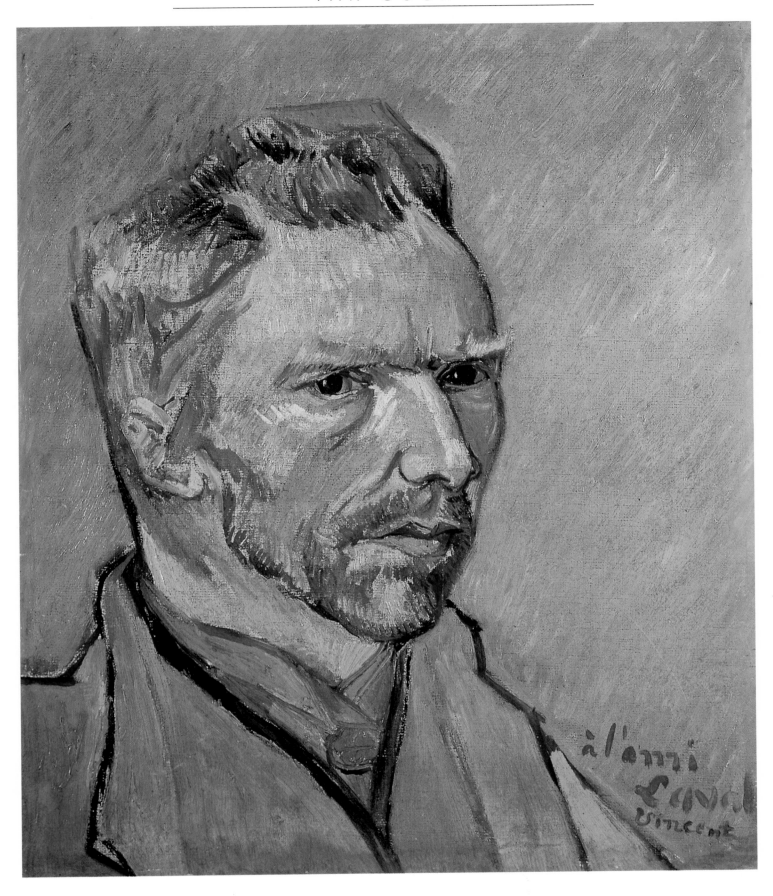

Self Portrait
Oil on canvas, 23 x 19 in.
Christie's Images,
London

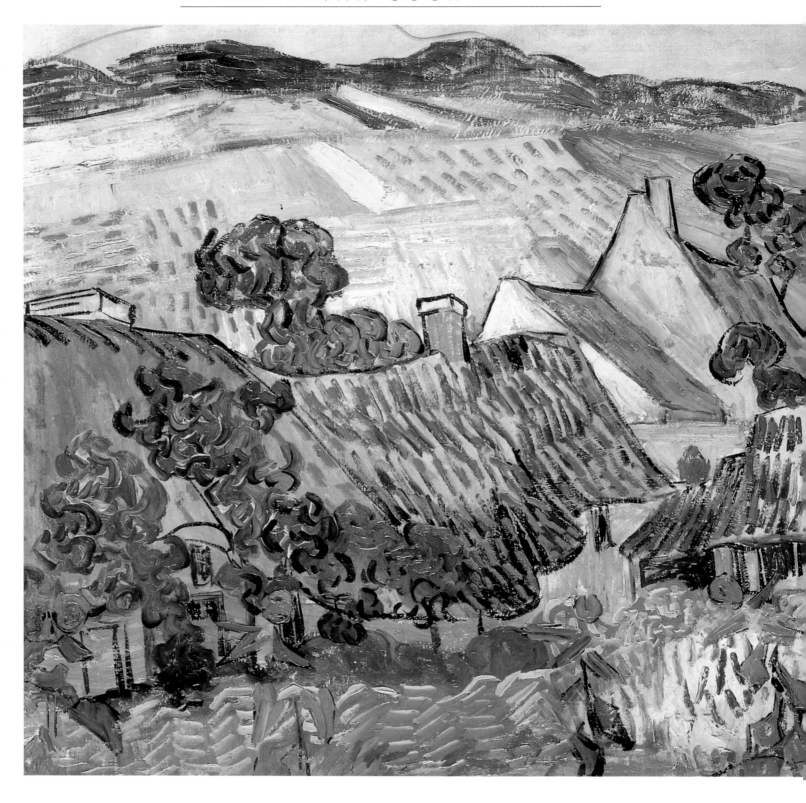

Farms near Auvers 1890
Oil on canvas, 19¾ x 39½ in.
The Tate Gallery,
London

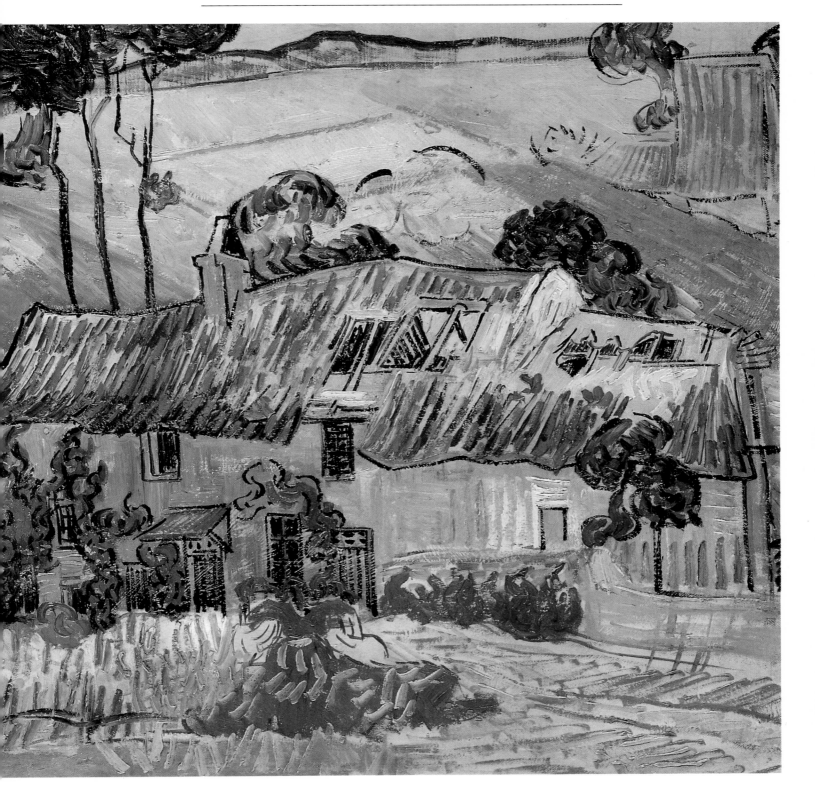

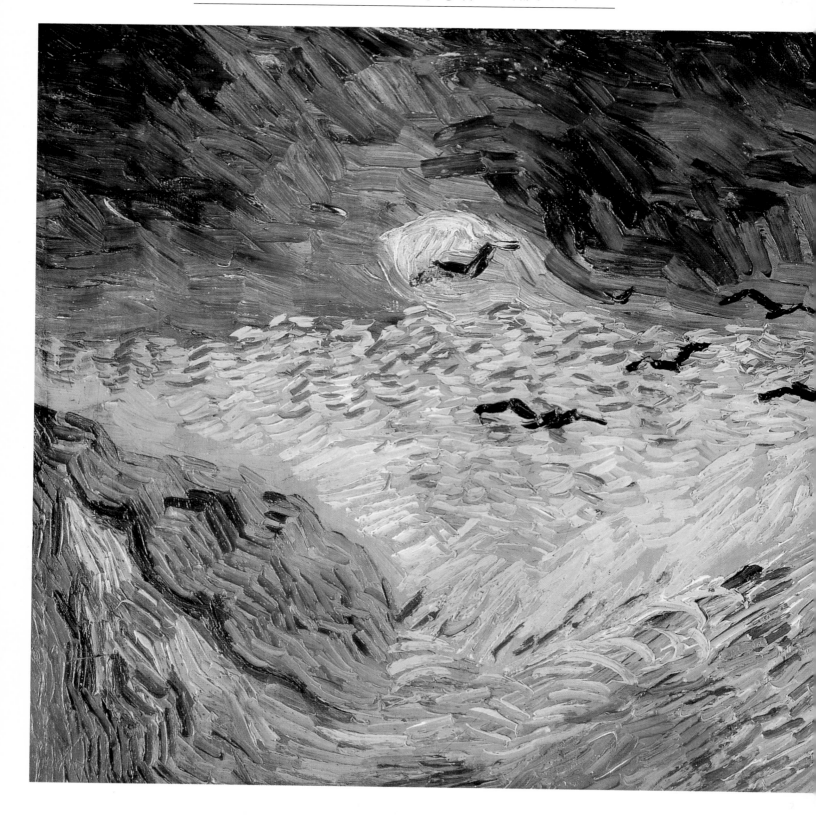

Crows over a Cornfield July 1890
Oil on canvas, 19¾ x 39½ in.
Rijksmuseum Vincent van Gogh,
Amsterdam

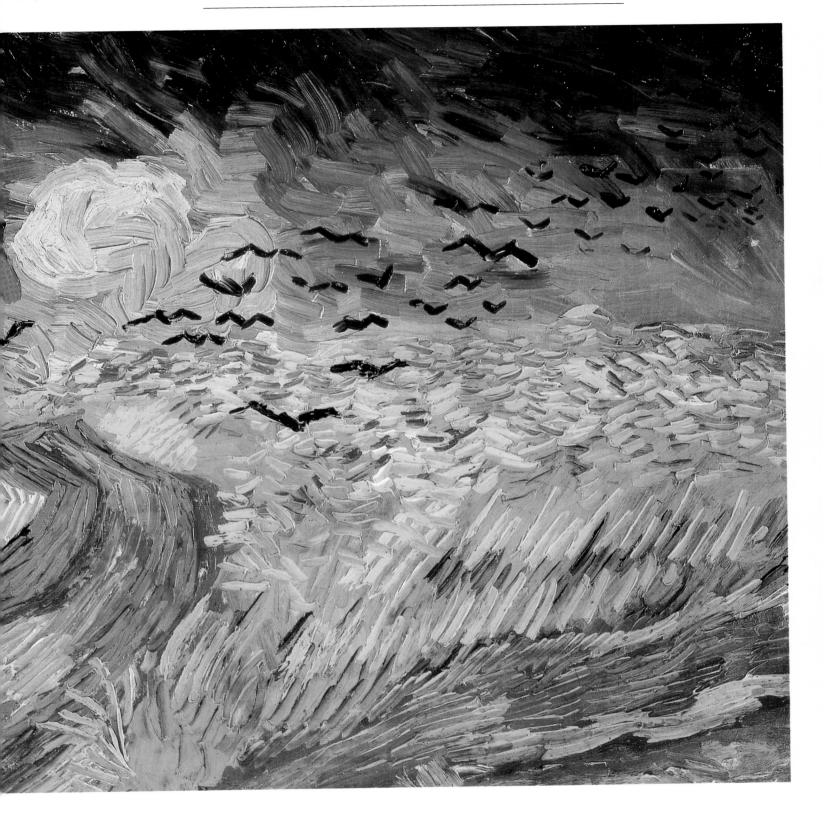

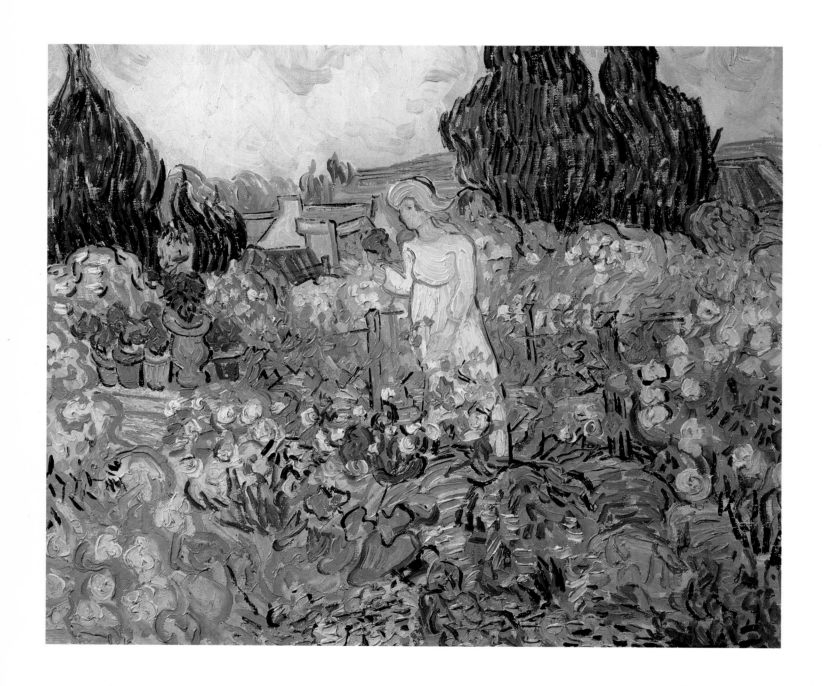

**Mademoiselle Gachet in Her Garden at
Auvers-sur-Oise** 1890
Oil on canvas, 18⅒ x 21⅗ in.
Giraudon/Bridgeman Art Library, London

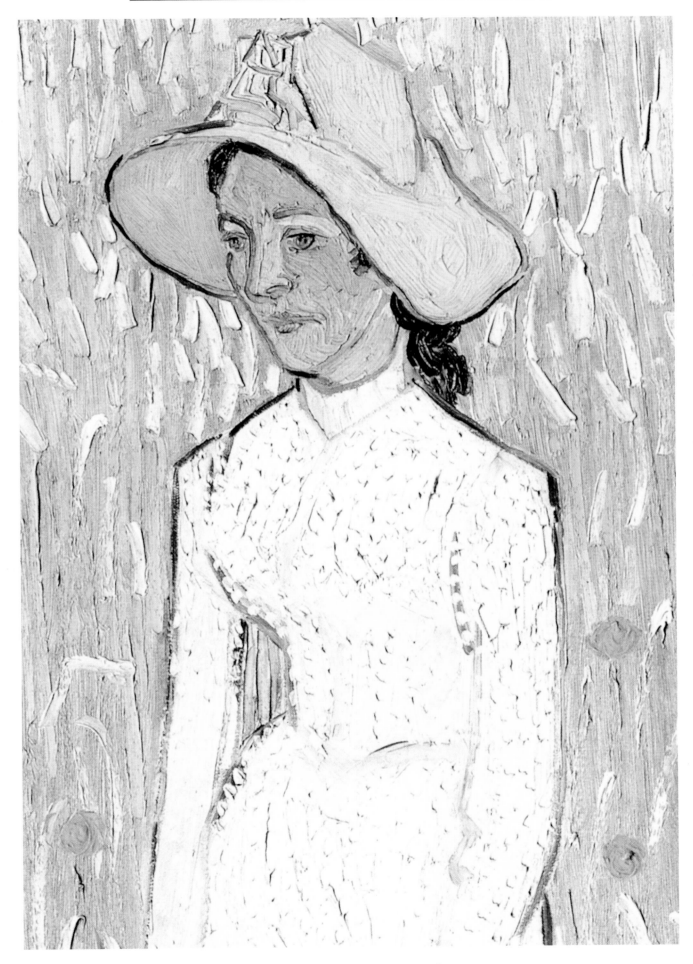

Young Girl in White June 1890
Oil on canvas, 26⅛ x 17⅞ in.
National Gallery of Art,
Washington, DC

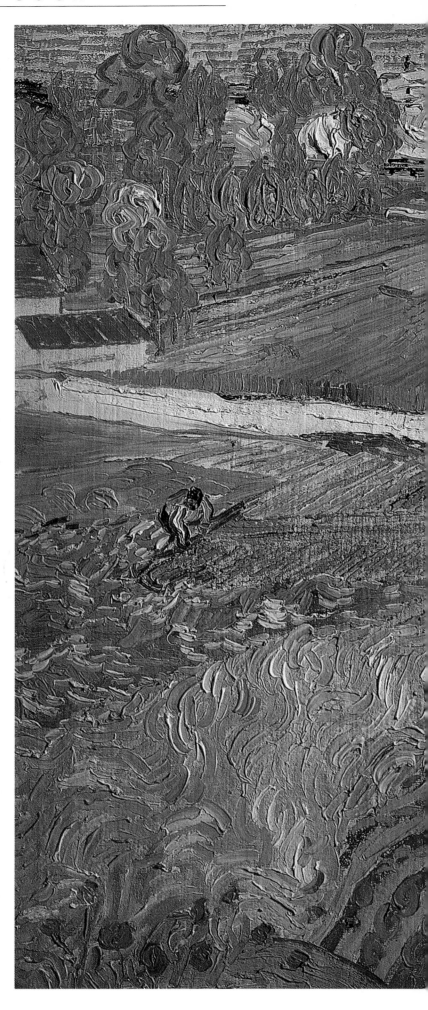

Landscape with Cart and Train June 1890
Oil on canvas, 28¼ x 35½ in.
Pushkin Museum of Fine Arts,
Moscow

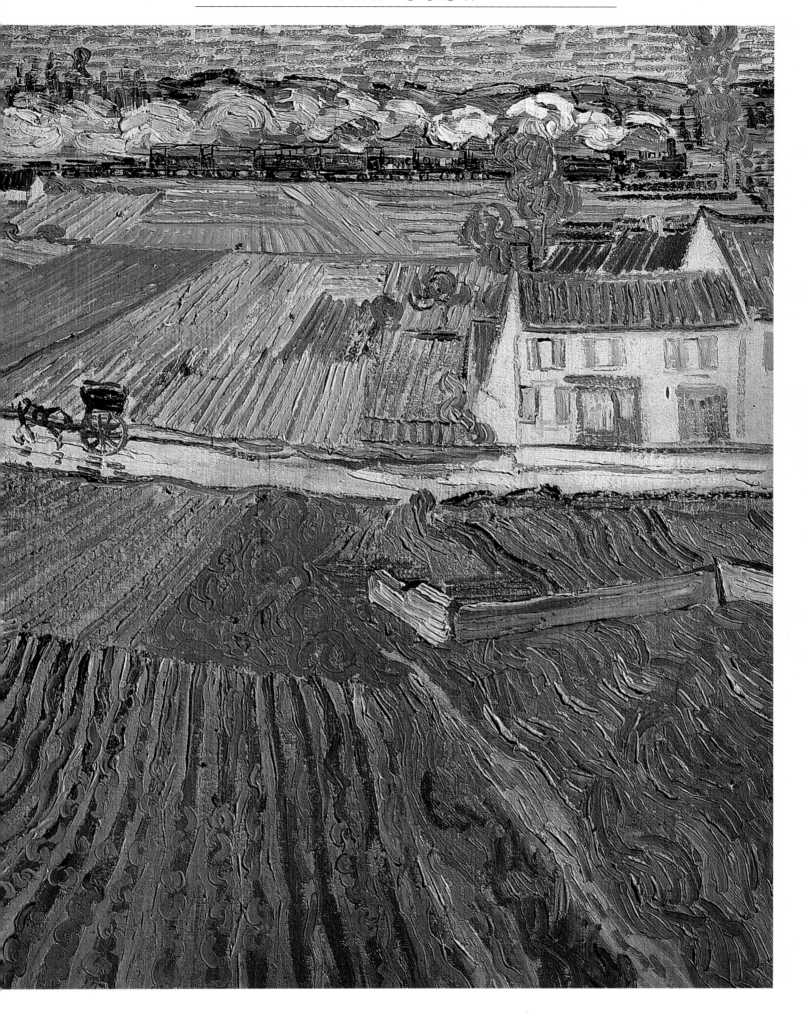

ACKNOWLEDGEMENTS

The publisher is grateful to the following institutions for permission to reproduce the pictures on the pages noted below:

via Bridgeman Art Library, London: 31, 42, 44, 50, 56, 58, 64/5, 68, 70, 73, 80/1, 92, 102, 124

Collection State Museum Kröller-Müller, Otterlo, The Netherlands: 1, 8(B), 12(B), 25, 26, 28/9, 30, 38, 46, 54, 56, 61, 62, 66/7, 72, 82/3, 86, 93, 104, 108/9, 112, 113

Courtauld Institute Galleries: 87, 90/1

Courtesy the Trustees of the British Museum: 16(R), 17

Christie's Images, London: 10, 27, 36, 40/1, 42, 68, 85, 119

Dallas Museum of Art: 51

Foundation EG, Bührle, Zürich: 48/9

Groningen Museum/photo John Stoel: 19(B)

Heydt Museum, Wuppertal, Germany: 58

Kunsthalle, Bremen: 102

Museum Boymans van Beuningen, Rotterdam: 23(B)

Museum of Fine Arts, Boston MA: 4, 7, 13, 71

Musée d'Orsay, Paris: 18, 25(B), 52/3, 55, 78/9, 103, 105, 106/7, 114/5, 116, 117

Musée Rodin, Paris: 2, 21, 60, 69

J. Paul Getty Museum, Malibu, CA: 94/5

Pushkin Museum of the Arts, Moscow: 80/1, 126/7

National Gallery, London: 89, 98/9, 110/1, Back cover

National Gallery of Art, Washington, DC: 125

National Gallery of Scotland: 15(T), 96

Oskar Reinhart collection: 92

Rijksmuseum Vincent van Gogh, Amsterdam: 6(all), 8(T), 12(T), 14, 15(B), 16(L), 19(T), 20, 21, 22(both), 23(T), 24(both) 32/3, 34/5, 37, 43, 44, 45, 47, 57, 59, 63, 70, 74/5, 84, 88, 97, 100/1, 122/3

© Photo RMN: 2, 18, 21, 25(B) 52/3, 55, 60, 69, 78/9, 103, 105, 106/7, 114/5, 116, 117

The Tate Gallery, London: 118, 120/1

Wadsworth Atheneum, Hartford, Connecticut, CT: 39

Walsall Museum and Art Gallery: 11 (Gorman-Ryan Collection)

Yale University Art Gallery, New Haven, Connecticut, CT: 76/7